THE VISIONARY EYE

THE VISIONARY EYE
Essays in the Arts, Literature, and Science

J. Bronowski

Selected and edited by Piero E. Ariotti
in collaboration with Rita Bronowski

The MIT Press
Cambridge, Massachusetts, and London, England

This book was set in V-I-P Palatino by Woodland Graphics and was printed and bound by Halliday Lithograph Corporation in the United States of America.

Library of Congress Cataloging in Publication Data

Bronowski, Jacob, 1908–1974.
　The visionary eye.
　Includes index.
　1.　Arts — Addresses, essays, lectures.　2.　Science and the arts — Addresses, essays, lectures.　3.　Imagination — Addresses, essays, lectures.　I.　Ariotti, Piero E.　II.　Bronowski, Rita.　III.　Title.
NX65.B696　1978　　700　　78-18163
ISBN 0–262–02129–3

CONTENTS

INTRODUCTION

All his life Jacob Bronowski treated art and science as the same expression of the human imagination. He wrote poetry side by side with his original theorems in algebraic geometry. In this collection of essays the theme of the imagination runs like a bright ribbon through the fabric of his thought.

In his many-faceted life he was mathematician, poet, philosopher, playwright, scientist, and teacher combined. His lectures given at MIT and later published as *Science and Human Values* opened the two-cultures debate.

When he joined the Salk Institute for Biological Studies in 1964, he found new interests in the origins of language, animal behavior, and the ongoing evolution in man. His diverse studies always seem to come back to the question, "What makes a man a man?" — the problem of what he called "human specificity." In one of his last statements he wrote:

What makes the biological machinery of man so powerful is that it modifies his actions through his *imagination*. It makes him able to symbolise, to project himself into the consequences of his acts, to conceptualise his plans, and to weigh them, one against another, as a system of values. We as men are unique. We are the social solitaries. We are the creatures who have to create values in order to elucidate our own conduct, so that we learn from it and can direct it into the future.

It was as a teacher that he agreed to make the television series called *The Ascent of Man*. As he said in it, "You have to touch people," and he reached out to millions, scientists and nonscientists alike.

The last six essays in this collection were given at the National Gallery of Art in Washington, D.C., as the A. W. Mellon Lectures for 1969, with the overall title *Art as a Mode of Knowledge*. These lectures were intended to complement his Silliman Lectures, *The Origins of Knowledge in Imagination* (Yale University Press, 1978), which he originally planned to call *Science as a Mode of Imagination*.

Unfortunately, when Bronowski died suddenly in August 1974, he had only just begun the work of revising the lectures as they had been delivered. The present six essays have been edited from the transcripts, together with the notes and outlines on which Bronowski was working. Every attempt has been made to pre-

serve the verve and immediacy of the original lectures, while at the same time providing some of the transitions and rephrasings which cannot be avoided in making a printed text clear and unambiguous. Modifications have been kept to a minimum: while every attempt has been made to check references and quotations, anecdotes and essentially incidental use of citation are left as they stand. By and large the text has been tampered with as little as possible.

I am grateful to Dr. Lisa Jardine and Sylvia Fitzgerald Bailey for this version.

Jacob Bronowski will be remembered especially for his remarkable, authoritative grasp of both scientific and literary culture. It is hoped that these essays will serve as a fitting memorial to his extraordinary range, diversity, and sensitivity.

Rita Bronowski
La Jolla, California

ACKNOWLEDGMENTS

Publication history

"The Nature of Art" was written as a preface for the 1966 edition of *The Poet's Defence* by J. Bronowski. Reprinted by permission of Thomas Y. Crowell Co., Inc.

"The Imaginative Mind in Art" and "The Imaginative Mind in Science" first appeared in the collection *Imagination and the University* (1964). Reprinted by permission of the University of Toronto Press and York University.

"The Shape of Things" first appeared in the February 1952 issue of *The Observer*, London, and is reprinted by permission.

"Architecture as a Science and Architecture as an Art" is based on a lecture delivered to the Royal Institute of British Architects and is reprinted by permission from the March 1955 issue of the *Journal* of the Institute.

Art as a Mode of Knowledge, the A. W. Mellon Lectures in the Fine Arts for 1969, are printed here for the first time by permission of the National Gallery of Art.

Permissions

Grateful acknowledgment is made for permission to quote from the following sources:

"Darius," from *The Complete Poems of Cavafy*, translated by Rae Dalven, copyright © 1961 by Rae Dalven. Reprinted by permission of Harcourt Brace Jovanovich, Inc., and The Hogarth Press Ltd.

Excerpt from "my father moved through dooms of love," from *Complete Poems 1913–1962* by E. E. Cummings, copyright 1940 by E. E. Cummings, renewed 1968 by Marion Morehouse Cummings. Reprinted by permission of Harcourt Brace Jovanovich, Inc., and MacGibbon and Kee Ltd.

Excerpt from "The Waste Land," from *Collected Poems 1909–1962* by T. S. Eliot, copyright 1930, 1939, 1943, 1950 by T. S. Eliot, copyright 1934, 1935, 1936, 1952 by Harcourt Brace Jovanovich, Inc. Reprinted by permission of Harcourt Brace Jovanovich, Inc., and Faber and Faber Ltd.

THE VISIONARY EYE

THE NATURE OF ART

In the summer of 1934 I came to the end of a long piece of mathematical research that had occupied me for two or three years. I had not given up my interest in literature during that time; on the contrary, I had gone on endlessly arguing about poetry, and I had just spent the winter with Robert Graves and Laura Riding doing that. But I had not had the leisure before, and the single-minded patience, to come to grips as I wanted with the problem of criticism that troubled me. Now I decided to seize the free moment to think and to write about the nature of poetry. It turned out to be a long moment: I finished *The Poet's Defence* late in 1937.

The problem that had been borne in on me ever since I was an undergraduate can be set out simply. As a mathematician, I had, of course, spent much of my time in the company of scientists. They talked vigorously about scientific work, their own and that of others, and past as well as present; they even talked about the philosophy of science, which was struggling with the daring ideas of relativity and quantum physics. What they had to say was always personal and direct, the talk of active men who worked in the same vein as their heroes and butted their heads against the same rocks. They spoke as equals about the labor of turning into fact what the imaginative mind conceives, and they spoke about the labors and the minds of the great and the small as if they were their own, from the inside. No doubt what they said was often callow, but it was never magisterial: no one thought of laying down the law to other scientists. To be a critic was not and is not a scientific profession.

But I had also edited a literary magazine at Cambridge, and had talked in the same way to those who wrote and read it. Here the tradition was subtly and yet wholly different. There was a respectable place for the critic as critic, and from the outset most of those who write, as well as those who read, were content with that. They crowded the lectures of I. A. Richards, and later of F. R. Leavis, and then went home to analyze poems in the manner of the master. And though the master's analysis was indeed searching, it was by nature and method the analysis of an outsider. It never gave the hearer the sense that he ought to ask himself how

he would set about putting his own thoughts into a poem. Did the critic ever think about which of *his* thoughts were fitted to go naturally into a poem? Could they by nature go into anything else? And if not, what did he do with the thoughts that poets made into poetry? How did poets come to dredge out of their heads the stuff that makes poetry and, they believe, nothing else?

With these questions in my mind, it was natural that I turned to the criticism written by poets themselves. For the questions imply a use of criticism that is different in kind from the judgments of professional critics, who treat the poem or the play as a finished artifact held up for our inspection. I knew that literary criticism in their sense could be interesting, in practice; yet it seemed and seems to me uninteresting in principle, as a form of knowledge. At bottom, I was looking not so much for a criticism as for a philosophy of literature.

The philosophy that I found in the critical writings of the poets whom I read is presented in the essays in my book, *The Poet's Defence*. In each of them, I tried to lay bare the poet's inner view of his own activity. That view has changed from age to age: on the whole, I found that poets have become less confident as their place in society has become less dignified. Yet the best poets, as I saw and see them, have almost always been sustained by the belief that they have access to a kind of truth that is direct and absolute and unique. For them and in them, literature is a profound and immediate form of universal knowledge.

The Poet's Defence was my first book, and I was happily surprised that it was very widely discussed. Those who read it did not all think well of it, of course. The widow of W. B. Yeats (he died while the book was being printed) was offended by what I said about the poet's sexual imagery in old age and took legal advice to know whether it was libelous. Laurence Housman was seething about my estimate of his brother. By way of balance, Desmond MacCarthy thought the essay on Yeats outstanding, and Edwin Muir thought the same of the essay on A. E. Housman.

Nevertheless, as I read what the critics wrote, I became aware that they had one thing in common: one and all, they were quite

unmoved by my argument. Those who believed, as I did, that poetry presents a universal truth went on believing it, certainly, after they read *The Poet's Defence*. And those who believed, as I did not, that poetry is merely another social utterance went on believing it, respectfully but firmly, after they closed the book. So far as I could learn, nothing that I had written had changed any reader's mind.

I was naturally chagrined by this immobility, and felt that I ought to be able to do better. There must be a more persuasive and concrete way to show the independence of poetry in the face of social change. The best argument would be empirical test; and there and then I made up my mind to find one. This is how I came to plan a second book on literature at a time when I had meant to write about mathematics.

The test that I conceived had to center on a moment in history when one society changed radically into another. How did poetry speak before the change, and how after it? I chose for the moment of change the Industrial Revolution, and set myself to compare the last great poet before it, Alexander Pope, with the first great poet after it, William Blake. It was not a study to which I went with any relish: I had never had a head for history, and Pope had left me rather cold and Blake rather impatient until then. Yet in a year I found all three fascinating, and in 1941 I finished the draft of a book called *Two Poets and a Revolution*.

The book about the two poets was cut in half by the hardships of printing and the uncertainties of writing in wartime. They persuaded me to get on with saying what I had to say most urgently, which was about the vision of William Blake. For I had found in him what had not been seen before, not an eccentric mystic, but an idealist with a sense of reality much broader than I had allowed for.

So I wrote an unexpected book about Blake, which (it turned out) gave a new direction to Blake criticism. The book about Pope was never written, though what I had found in him was also startling. I have kept an affection for him and for the other defeated men in the Scriblerus Club, but I do not suppose that I shall ever write my account of that island in literature.

I must not end this story of the origin and the outcome of *The Poet's Defence* without saying how the book strikes me now. It is, I see, a more complex study than I thought when I wrote it. Then, it seemed to me a plain exposition of what eight admired poets revealed about the power and place of poetry in their minds when they happened to write out their thoughts discursively. True, what they had to say about the central concept of poetry was bound to be overlaid by their personal quirks and their social preconceptions. Yet I had no doubt that the close reader and lucid reasoner could lay bare under the tangled feelings a single vision in each poet without doing violence to his thought.

And this bold aim did reach important findings. It showed a coherence in the progress of poetry that was not merely historical but philosophical. Indeed, it pointed the way to a philosophy of poetry in the same sense in which there is a philosophy of science: a compact body of ideas that is formed by and that informs its most original minds. Such a philosophy is quite unlike the habitual view of nature and of man with which the rest of us get through our lives from day to day. It is less concerned with social action; it is more inward, absolute, and ideal. I fell short of my aim, it seems to me now, only in missing the greater richness of the poet's ideal over that of the philosopher.

The method of poetry demands of the poet that he express his thought concretely, in images. This is not so much a technical demand as a demand of intellect and temper. Intellectually, it holds the poet to a scheme of thoughts that can speak in the direct language of experience. And temperamentally, it attracts and selects those men in whose mind abstract ideas are symbolized by concrete happenings. These characteristics in the best poets, which derive from the nature of poetry, do not make their ideal of truth less absolute, but they make it less narrow than I once thought. Nowadays I would say about the preoccupation of the poet what I said when I wrote about William Blake:

It is the belief of imaginative poets, of whom Blake was among the first, that they are the symbol and the voice of universal experiences more lasting than the accidents of time. The poets of Augustan wit and invention who dined with Swift would have thought this claim extravagant. And it is doubtful whether the

claim is ever made by poets who feel at home in their time. Nevertheless, the more impassioned poets are surely right. Poetry does speak from one age to another, because it is founded in experiences which are simple, common, profound, which are human and universal. But alas! to the generations of Belsen now and Peterloo then, the timeless human experiences do not end at love, beauty, truth, and passion. They embrace poverty and fear and injustice and chicane, the loss of place and the social disasters.

After this, there remains one deep question to answer. How is it that the poem can pass these grave truths from the poet to the reader directly, as it were, and all of a piece? What is it in literature that makes it able to communicate not simply pleasure but knowledge? Allen Tate, in *The New Republic,* pointed to this as the crucial problem that *The Poet's Defence* posed: "Bronowski is saying that unless epistemology can ask real questions, then poetry becomes as unreal as philosophy; there remain only sensation for poetry and the empirical method for science."

I have pursued this problem ever since, in writing about science and philosophy as well as about literature. For there is a common pattern to all knowledge: what we meet is always particular, yet what we learn from it is always general. In science we reason from particular instances to the general laws that we suppose to lie behind them, and though we do not know how we guess at these laws, we know very well how to test them. But in a poem the specific story and the detailed imagery that carries it create in us an immediate sense of the general. The experience is made large and significant precisely by the small and insignificant touches. Here the particular seems to become general of itself: the detail is its own universal.

I have no doubt now that there is a common quality in science and in poetry — the quality of imagination. But I have no doubt either, thirty years after *The Poet's Defence,* that what I held there is true: the imagination reaches us, reaches into us, in different ways in science and in poetry. In science it organizes our experience into laws on which we can base our actions in the future. But poetry is another mode of knowledge, in which we become one with the poet and enter directly into his and into all human experience.

THE IMAGINATIVE MIND IN ART

My subject in this essay and the next concerns the arts and the sciences, and in this first essay I shall confine myself to the arts. The art from which I shall draw most of my illustrations is literature, and more particularly poetry. I choose the field of literature because it has the advantage that its raw material is simply words. But I ought to say at once that this raw material is no less subtle or less sophisticated than that of any other art. The human race was not given words as it was given hands and feet, as part of its inborn endowment from nature. Literature begins with language, and it is relevant to begin by saying something about the history and nature of human language.

It is not certain when human beings started to speak, but it was certainly not very long ago, on the time scale of evolution. We believe that human beings became clearly differentiated from the common ape stock about a million generations ago. However, human speech is probably not much older than a hundred thousand years. The whole of human converse as we know it fits into this small fraction of our evolution.

The raw material of literature is not simply words, but words as human beings use them; and human beings do not use language in the limited way that animals do. There is a cardinal difference between human language and animal languages. Let me begin, then, by comparing the two, and specifically by describing an animal language.

Many species of animals have some kind of language. Some of them, for example the insects, have a language which is certainly older than our own. I shall take as my example one of these old insect languages: the language of the bees.

It has been known for two hundred years that when a bee which has found a source of honey returns home, it makes a violent agitated movement which in time is taken up by the whole hive. The beekeepers who first noticed this in the eighteenth century supposed it to express a primitive emotion. They believed that the bee comes home in a state of excitement, and that it simply communicates this excitement to the other bees in the hive. However, they were wrong; the communication between bees is more precise and more remarkable than mere excitement.

It has now been shown by the delicate studies of Karl von Frisch and others that the bee that comes home laden with honey talks to the other bees in the hive in quite specific symbols. The returning bee does a round dance, shaped like a flattened figure of eight, and other bees take up this dance and begin to follow the leader along its figure of eight. This figure of eight has two exact messages for the bees that follow it. The direction in which the main line of the figure points tells the bees in the hive where to go for the source of the honey that they smell on the leader. And the speed at which the figure is run tells the bees how far away the source of honey is.

I apologize for telling this story so briefly and so roughly, because those who already know it will know it more fully, and those who do not know it will scarcely believe it. Yet the story is true and, in its essence, is as simple as this. The dance of the bees is a complete instruction by which one bee tells the others in what direction to fly and how far to fly. The bees that take up the dance learn the instruction by actually following the movements of the first bee in the dance — that is, by going through the same steps as if they themselves had brought the message.

This is characteristic of the language of any animal, even when it utters something as simple as a cry of alarm. What the animal says is very specific: it communicates a piece of information to the other animals. The other animals do not hold a meeting about what they are told, do not discuss it or consider it or even reflect on it. When a group of monkeys hears the cry of alarm of its sentry, it scatters. When a hive of bees observes the dance of the homecomer, it carries out his instructions without argument — at least, so long as there is only one homecomer.

Human beings also have a language of instruction and information. For example, my description of the behavior of bees has been as specific as their own language. True, my description does not instruct you what to do; but that is only because you are not a bee. Essentially, I have given you (or tried to give you) an uncolored piece of information, which in itself makes no demand from you but simple assent. This is the language of communication.

But human beings also use language for quite a different purpose: for personal reflection and elaboration. When you have finished reading this essay, you will go away and think about it; and you will think about it in your personal language, privately. You may begin by thinking about the behavior of bees, and then your thoughts will go off elsewhere, to subjects which have no more to do with bees than the rest of my essay has. You will reflect, you will make analogies and draw conclusions, and all this you will do by manipulating inside your head all the ideas that are touched off by, say, the idea that bees talk. This is the ability that makes you human: the use of words or symbols, not to communicate with others, but to manipulate your own ideas inside your own head.

Let me pause to underline this critical point. I began by saying that the raw material of the art of literature is words. Now I have made a distinction between two kinds of words, or rather, between two uses of words. On the one hand, there are the words of command or communication — words which are mere signals, and tell us, as it were, to stop or to go. The language of bees and monkeys and other animals is made up of these words, and does not go beyond them. On the other hand, human language goes beyond these words of communication, and uses words also in order to formulate ideas inside our minds. We reflect on our own ideas, we change them and enlarge them, and they carry our personal associations for us. It is words in this sense which are the vehicles of our imagination, and the raw material of literature.

How do we know that human beings use words in this way, to recreate the world inside their minds? And how do we know that animals do not? We know it by experiment — by watching the experiment which nature carries out before our eyes every day, of slowly transforming a young animal or child into an adult. We know it, that is, by watching the development of the young, and seeing whether they do or do not ever reach the stage of thinking about something which is not present in front of their eyes or other senses.

We can actually watch and see the stage at which a child learns to use words for objects which are not immediately present to

him. Anyone who has had a baby, and who is reasonably percep-
tive, has seen this moment. There comes a stage in a child's life,
before he is twelve months old, when he visibly takes the great
step. Before this stage, if you show a child a toy and then put it
behind your back, his interest disappears: he is not aware of ob-
jects which are not in his actual field of sensation. And then one
day there comes a moment when the child is aware that the toy
behind your back is still a toy — it is still somewhere, it exists, and
it will return.

This is a huge moment of illumination, not only in your child's
life, but in the whole evolution of the human race. The ability to
conceive of things which are not present to the senses is crucial to
the development of man. And this ability requires the existence of
a symbol somewhere inside the mind for something that is not
there. Of course the young child does not know the word "toy";
but he has in his head some image which says, what was in my
field of vision was a toy, it still exists, and it will return.

Probably the images that we use most often in the mind are
words themselves. But all our symbols have the same purpose;
words are merely the symbols we use most commonly. The func-
tion of words in human thought is to stand for things which are
not present to the senses, and to allow the mind to manipulate
them — things, concepts, ideas, everything which does not have
a physical reality in front of us now.

The enlargement of experience which comes from the use of
symbols is perhaps most tellingly presented as a numerical ac-
count. Consider, then, one of the relatives of man that has been
studied — say, the rhesus monkey.

Rhesus monkeys have a fair vocabulary. They can make about
twenty sounds and about twenty gestures, so that they have a
total of about forty distinct words. Of course these are all com-
mand words, such as "come here," "go away," or else words
(including gestures) which convey strong emotion.

Now compare the monkey's vocabulary of forty words with a
reasonable human vocabulary. In round figures, a man's vocabu-
lary is at least a hundred times as large. That is, four thousand
words is a fair vocabulary that a human being can get along with,

if he is not going to spend too much time in thinking. And the total store in a good dictionary is more than a hundred times larger again, for a good dictionary contains nearly a million words.

This, then, is a measure of the distance from the language of command to the language of ideas. The language of ideas creates a different universe: a universe which has multiplied the monkey's vocabulary of forty words to the million words in a human dictionary. Moreover, a monkey knows all the words in the monkey dictionary; but a human being, though he knows a hundred times as many words as a monkey, still knows less than a hundredth of the words in a human dictionary.

Let me take one more step in this description of the raw material of one of the arts, of the evolution of language or symbolism. I have described the great step which human beings take as children when they become aware of more than is in front of their senses. When the human species became able to hold absent things in the mind, it took a critical step in its evolution. Why do I think this step is so critical?

The ability to hold absent things in mind gives human beings a freedom inside their environment which no animal has. Animals are environment-bound: that is, they react to outside stimuli in a tightly limited way. They have little choice of response. Much fascinating experimental work shows that an animal which has a strong stimulus in front of it is not able to resist its compulsion. Whether the stimulus is food, or is the affection of a hen for her chicks, the animal is unable to make any response but the obvious one. It rushes straight for the food or the chicks; and if there is some obstacle in the way, the animal is so much dominated by what is in front of its eyes that it cannot remember its way round the obstacle. The animal has no words, no mental images, which allow it to visualize anything but the situation in front of its senses.

By contrast, the language of human beings gives us the ability to see ourselves in a thousand situations which are not present to us, and never may be. Foresight is a characteristically human at-

tribute. Only human beings are capable of projecting themselves into imaginary situations, and considering a week ahead, "If it snows I'll have to wear my galoshes, but if it doesn't snow I'll be able to wear my new shoes." And this we can do only because we have words like "snow" and "galoshes" and "new shoes" all going round inside our heads without any of these things having to be physically in front of us.

I have used the word "imagination" in the titles of this essay and the next because it is the right word to describe the most human gift. Imagination simply means the human habit of making images inside one's head. And the ability to make these personal images is the giant step in the evolution of man and in the growth of every child. Human beings can imagine situations which are different from those in front of their eyes; and they can do so because they make and hold in their minds images for absent things.

A child can remember absent things quite early, but he cannot do imaginary actions with them until much later in his development. When the child takes this second step, when he discovers his own imagination, he suddenly walks into a new life. At this moment, the child opens a door into the world beyond his immediate experience, because he is now seeing situations that do not exist. The child treats these imaginary situations in part as fantasy, and in part as a quite rational exploration of future experiences. A child's play does both: it frolics in the fantasy world, and it experiments in the rational world, which are both created by these images. This is why children love to make up fairy stories, and also love to play at marriage and hospitals and all the rituals of adult life. They project themselves into all worlds, possible and impossible, and discover for themselves the knife-edge boundary between them.

The ability to make images for absent things, and to use them to experiment with imaginary situations, gives man a freedom which an animal does not possess. That freedom has two distinct parts. One part is the pleasure that human beings feel in trying out and exploring imaginary situations. A child's play is con-

cerned with this pleasure; and so is much of art, and much of science too. At bottom, pure science itself is a form of play, in this sense.

The second part of the freedom which words and images give us is that they are personal to us. All bees have exactly the same language; when one bee dances, the other bees listen simply by imitating the same dance. The bees have only one vocabulary, with the same words and the same meanings. But human beings, because they manipulate words inside their minds for themselves, change them and develop them and give them their own meanings. No two human beings, not even identical twins, speak quite the same language.

This personal manipulation of language, this gift of recreating for ourselves, in a fresh way, the images which other people present to us, is the foundation of art. When you read a poem you all see the same words, and yet each of you makes the poem something different and personal for himself. You pick out odd points, you hear different overtones, new analogies start up in your mind. And this is individual to you, and forms a complex amalgam which is yours and no one else's — indeed, which in the end is you.

It is time to end this analysis of the raw material of an art, and to turn to the art itself. Let us consider the following poem by Dylan Thomas.

The force that through the green fuse drives the flower
Drives my green age; that blasts the roots of trees
Is my destroyer.
And I am dumb to tell the crooked rose
My youth is bent by the same wintry fever.

The force that drives the water through the rocks
Drives my red blood; that dries the mouthing streams
Turns mine to wax.
And I am dumb to mouth unto my veins
How at the mountain spring the same mouth sucks.

The hand that whirls the water in the pool
Stirs the quicksand; that ropes the blowing wind
Hauls my shroud sail.
And I am dumb to tell the hanging man
How of my clay is made the hangman's lime.

The lips of time leech to the fountain head;
Love drips and gathers, but the fallen blood
Shall calm her sores.
And I am dumb to tell a weather's wind
How time has ticked a heaven round the stars.
And I am dumb to tell the lover's tomb
How at my sheet goes the same crooked worm.

As in many of Dylan Thomas's beautiful poems, the central thought here is simple. It consists of the confrontation in each verse of the same two ideas.

One is the idea of the green fuse, the power in nature that drives everything forward; we feel this, we share its activity, and it makes us feel stronger and bolder with each experience, and life and time seem to be on our side. The second idea in each verse is that we are, however, being destroyed by this very same power. We are getting older, life and time are killing us a little with each experience. I suggest reading the first verse again; it shows the contrast of the two meanings clearly — the predicament of all living and growing things.

However, I did not choose this poem in order to discuss its philosophy. I chose it to illustrate the nature of human language. Here the very act of exploring the medium of his art, of exploring the language, is an excitement to the poet. The poet must take pleasure in discovering what language can do; that is his starting point. And this sense of pleasure is obvious in the poem; it is obvious that Dylan Thomas was not merely in love with poetry, he was in love with words.

If we think of the poem as a formal statement, then it is rather repetitive: each verse restates the same simple thought which one could write out in two lines. The same thought is illustrated by images from different fields — in verse one they are trees, in verse two water and rocks, in verse three whirlpools and quicksand, and in verse four inevitably the images relate to love. And yet each of us is aware that when he comes to the end of the poem, my restatement of it only brushes a fringe of what the poem says to him. In some way the imagery which Dylan Thomas runs through his hands so prodigally touches each one of us at one spot or another on the raw.

Whether you are the person on whom the word "hangman" in the third verse strikes like thunder, or whether to you the word "love" in the fourth verse comes like a revelation, it is you individually who has been moved. Something in this lavish imagery reaches each of us, and has the effect of carrying a personal message to each of us. My dry prose statement of the meaning of the poem means much the same to each of us, and that much the same is very little. But the poem itself is rich in meaning because everyone makes his or her own poem out of it. What poem you make out of it depends on which of the images suddenly sets you on fire. I am captured by the word "fuse" in the first line, and its explosive urgency carries me headlong into the poem from the beginning. Ask yourself what image rises from the poem like a rocket for you, and spills a bright rain of light over your understanding.

Everyone of us reads the same poem, and yet each one of us makes his own poem. This is the nature of imagination: that everyone has to reimagine, and to reimagine for himself. Dylan Thomas certainly imagined this poem first, certainly created the poem. And yet, if you want to understand the poem, you have to recreate it for yourself.

This is a strange thought, but it is fundamental. No work of art has been created with such finality that you need contribute nothing to it. You must recreate the work for yourself — it cannot be presented to you ready-made. You cannot look at a picture and find it beautiful by a merely passive act of seeing. The internal relations that make it beautiful to you have to be discovered and in some way have to be put in by you. The artist provides a skeleton; he provides guiding lines; he provides enough to engage your interest and to touch you emotionally. But there is no picture and no poem unless you yourself enter it and fill it out.

I chose Dylan Thomas's poetry as the first example because it illustrates so clearly what the poet can give and what we must add. If this had been a bad and unsuccessful poem, we would all say instantly, "This poet is threshing about; each verse tries a new spurt of imagery; he is trying to blunder his way toward saying

the thing right, by mere repetition." And that is true of Dylan Thomas; yet when his poem comes off, you see that it is marvelous. But it is true that this is what Dylan Thomas is trying to do: he is trying by any means to find a way into your personality so that you may reimagine his simple thought for yourself. You must be faced with the thought in your own way, and seize it for yourself.

What thought? The thought that when you are young, growing older is wonderful, but when you are old, growing older is tragic. For that is what the poem says. It does not say it in any single line or in any single image, yet that is what it says somewhere. At least (I beg your pardon) that is what the poem says to me — or better, that is what I say to myself through the poem. And even this expression is not quite right: that is one part of what the poem says to me, or of what I say to myself through the poem.

I have called the metaphorical figures of speech in the poem its imagery, and that is a fair reminder: it is the poet's images that set off our own imagination. The metaphorical images work in our minds, and shape our thought and are the essence of it. The fact that the metaphors in the first verse are of growing things, and in the second verse are of water and rocks — this gives the poem its quality. Each verse draws in a different field of experience, and it might seem that none is essential to the poem. "When you are young, growing older is wonderful, but when you are old, growing older is tragic" — surely it is true that none of the metaphors by which that is conveyed is a necessary part of the statement. But it is also true, and more deeply true, that without the metaphors the statement becomes meaningless. The metaphors link the different fields of our experience and seek out the likeness between them.

When Dylan Thomas says, in his first verse, that the sap which pushes through the branch to burst into leaf and flower is also the force that bursts the roots, he is not merely making my prose statement more vivid. He is joining one area of experience to another, and illuminating and enriching each with each. The images of growth in the first verse, the images of fertilizing water in the second, the mounting death images of the hangman in the

third verse, and the ambivalent images of love in the last verse: these join together to make a poem exactly as a man's experiences join together to make a personality. In this sense, all art is metaphor. It takes one part of your experience, and another part of your experience, and it forces you to look at them together. And by this act of looking at them together, the work of art makes you see each experience afresh and differently.

Now, to close my essay, I ought to turn to the other of the two freedoms which I said human language gives us. One is the freedom to be personal, to enjoy the implications of the language for ourselves and to be stimulated by it. That I have displayed in detail in Dylan Thomas's poem, and in the highly personal recreation of the poem which each of us makes for himself. The other is the freedom to imagine different courses of action, and to explore their possibilities in the mind, one against the other.

The ability to foresee several different courses of action and to weigh them in the mind might be thought to be a purely logical and scientific faculty. But in fact, this is the nature of all imagination, in art and science alike. In this simple respect, there is no difference between a great theorem, like that of Pythagoras, and a great poem like Homer's *Iliad*. The difference lies at a deeper level: Pythagoras is deliberately trying to mean the same thing to everybody who listens to him — one thing and one thing only — and Homer is not. Homer is content to say something universal and yet to mean different things to everybody who listens to him. We know this, we have just heard it. We know that Dylan Thomas's thought, because it deals with youth and age, evokes a different poem in a young reader from that which it evokes in an older reader.

But this is not yet deep enough; we must go deeper still to understand the full power of a work of art. A poem does not present a number of alternatives in order to invite you to come down for one or another. The poem asks you to weigh them, but not to judge them: unlike the theorem of Pythagoras, it is not a blueprint for action. On the contrary, the poem or other work of art is so arranged that it positively discourages you from deciding which

of its imaginary actions (which of its possible meanings) you like best and should follow.

Turn back to the poem by Dylan Thomas and the two conflicting things that it says in each verse. At the end of the to-and-fro, are you joyful at the thought that growing older is wonderful when you are young? Or are you cast down at the thought that growing older is tragic when you are old? Neither; you cannot make up your mind. And the poem, unlike the theorem of Pythagoras, is not meant to make up your mind for you. On the contrary: fundamentally and literally, the poem is deliberately arranged to prevent you from making up your mind.

I shall illustrate this important point, my final point, with a poem by Robert Frost. It is not a lyrical poem; it has no bright and poetic imagery of evocation; and neither is it one of those milk-and-honey poems into which Frost often lapsed. It is a tough and searching and extraordinary poem, and it is called "Provide, Provide."

The witch that came (the withered hag)
To wash the steps with pail and rag
Was once the beauty Abishag,

The picture pride of Hollywood.
Too many fall from great and good
For you to doubt the likelihood.

Die early and avoid the fate.
Or if predestined to die late,
Make up your mind to die in state.

Make the whole stock exchange your own!
If need be occupy a throne,
Where nobody can call *you* crone.

Some have relied on what they knew,
Others on being simply true.
What worked for them might work for you.

No memory of having starred
Atones for later disregard
Or keeps the end from being hard.

Better to go down dignified
With boughten friendship at your side
Than none at all. Provide, Provide!

The imagery of this poem belongs to our own generation. It uses the verb "to star," for example, not for poetic effect, but simply to describe a Hollywood celebrity. Elsewhere it chooses equally direct phrases of today, such as the command to make the whole stock exchange your own. That is, the poem is deliberately worded to draw in fields of experience which you will feel to be relevant to your own life.

The story in the poem is also clear and contemporary. The poet meets a woman who has been a great star in her past, and now she is nothing. He reflects that people have dealt with the problem of old age in various ways. You can avoid it by dying early; but if you must grow old, then you had better ensure that you keep your dignity at any price — even if you have to buy it. The moral would be (if there were a moral), Do not become a fallen star: provide for your survival, whatever its cost, by any means at all, however mercenary, flamboyant, or tawdry.

But do you really think there is a moral? Do you know whose side you are on, or Robert Frost is on? Do you really believe that Frost meant to tell you that it is better to provide for your old age by buying friends, than to live with the memory of having starred? Of course not; the poet is not giving you this advice — and neither is he giving you the opposite advice.

The poet is not giving you advice at all. He is not asking you to accept a moral, or even to draw one for yourself. The universe of art is one in which there is a suspension of decisions, what Samuel Taylor Coleridge called a willing suspension of disbelief: a suspension of the sense of judgment.

There are no morals in a poem; there are no morals in any work of art. There are no specific lessons to be learned and there is no advice to be followed. There are many implications in a poem which enrich our experience of life: but it is a many-sided experience, and we are not supposed to come down on one side or the other. Dylan Thomas confronting two issues for us in each verse, or Robert Frost with a macabre sense of humor pretending to teach a lesson which he does not want us to learn, epitomizes the nature of art. Here the imagination explores the alternatives of human action without ever deciding for one rather than another.

And in this tense and happy indecision, and only in this, the work of art is profoundly different from the work of science.

In the next essay I shall consider the great likenesses between art and science which are to be set against this single difference.

THE IMAGINATIVE MIND IN SCIENCE

This essay is a continuation of the preceding one: its theme is to draw not the differences but the likenesses between the imaginative faculty in art and in science.

The art which I chose to illustrate my first essay was the art of poetry. The raw material of this art is words — but words as human beings use them, not as animals do. The language of most animals, as I noted in that essay, has about forty distinct words in it, and they are all words of command or communication and nothing else. An animal can say "come" and "go" and "I am suspicious"; a flight of rooks can even say "We are going home." But only human beings can say "We hope it will be a nice day when we come back tomorrow." Only human beings have conceptual words like "tomorrow" and "nice day," by which they fix and manipulate in the mind things which are not present to their senses.

The existence of words or symbols for absent things, all the way from "nice day" to "ultimate deterrent," enables human beings to think themselves into situations which do not actually exist. This gift is the imagination, and it is simple and strong, for it is no more than the human ability to make images in the mind and use them to construct imaginary situations.

Science uses images, and experiments with imaginary situations, exactly as art does. That will be the starting point for the likenesses which I shall draw here. To believe otherwise, to suppose that science does not need imagination, is one of the sad fallacies of our laggard education. I shall be traversing several of these popular fallacies about science in the progress of this essay.

A child discovers before he is a year old that an object which he sees and which is then taken away continues to exist, and in time will return. This is the first great step of human development, when out-of-sight ceases to be out-of-mind.

Several years later in his life, the child takes the second and greater step. He now makes an image of the absent thing, and is able to use the image to think himself into unknown situations. At that moment, he enters the gateway to all imaginative thought — and this includes the processes of thought which we use in reasoning.

Many people believe that reasoning, and therefore science, is a different activity from imagining. But this is a fallacy, and you must root it out of your mind. The child that discovers, sometime before the age of ten, that he can make images and move them around in his head has entered the same gateway to imagination and to reason. Reasoning is constructed with movable images just as certainly as poetry is. You may have been told, you may still have the feeling, that $E = mc^2$ is not an imaginative statement. If so, you are mistaken. The symbols in that master-equation of the twentieth century — the E for energy, and m for mass, and c for the speed of light — are images for absent things or concepts, of exactly the same kind as the words "tree" or "love" in a poem. The poet John Keats was not writing anything which (for him at least) was fundamentally different from an equation when he wrote,

Beauty is truth, truth beauty, — that is all
Ye know on earth, and all ye need to know.

There is no difference in the use of such words as "beauty" and "truth" in the poem, and such symbols as "energy" and "mass" in the equation.

We do a great harm to children in their education when we accustom them to separate reason from imagination, simply for the convenience of the school timetable. For imagination is not confined to wild bursts of fantasy. Imagination is the manipulation inside the mind of absent things, by using in their place images or words or other symbols.

Imagination is always an experimental process, and this whether we are experimenting with logical concepts or with the fancy-free material of art. We can see this from the beginning in the play of children. A great deal of childhood play consists of acting in imaginary situations — pretending to get married, pretending to be a doctor and nurse and patient, putting two chairs together and pretending to build a house or run a train. And all this acting is a form of experiment — experimenting with situations which are not real, but which may become real. This is why imaginative play is an activity of great importance in the child's development: be-

cause it is the basic activity by which he experiments and, as it were, tries out the shape and feel of the future.

Many animals play, and in their play unconsciously experiment with the future. A kitten chasing a ball of wool is carrying out a minute and happy experiment; it is learning its way (and its own skill) into the hunting situations which it has not yet experienced. Evolution has worked to prepare kittens and puppies and bear cubs and many higher animals for their adult actions, by this mysterious method of play, long before they enter into the adult life of action. And human beings owe much of their headlong progress in evolution to the fact that they carry out this experimental activity for a much longer time than other animals. We have a longer childhood: we play and experiment longer. We invest more of our time in our own education; and our education, formal and informal, is constantly intended to make us experiment with imaginary situations.

The kitten chasing a ball of wool is learning, unconsciously, a physiological command over its own skill which will enable it to survive in an environment which it has not yet met. It is, as it were, feeling out and filling out its own physical muscles. The child playing a make-believe game is feeling out and filling out its intellectual muscles. And this imaginative activity gives the child confidence and freedom over his future environment. The word "experiment" is an exact description of what the child is doing. And this, the basic word in science, is also an exact description of what the adult does whenever he is doing anything original at all. A physicist experiments with material situations whose properties he does not wholly know, and a poet tries to find his way through human situations which he does not wholly understand. Both are learning by experiment. And both are experimenting with situations which they must imagine before they can create them. "What is now proved was once only imagin'd," said the poet William Blake.

If science is a form of imagination, if all experiment is a form of play, then science cannot be dry-as-dust. Yet many people suppose it is; this is another popular fallacy, that art is fun but science is dull.

Neither art nor science is dull; no imaginative activity is dull to those who are willing to reimagine it for themselves. Of course, many individual scientists are personally dull; but I assure you, after a lifetime of suffering both, that many artists are dull people too. But they are not dull inside their work — neither the artists nor the scientists. Inside their work they are at play, they are imagining and creating new situations, and that is the greatest fun in the world for them — and for us, if we can recreate their work.

Science or art, every creative activity is fun. This is true not only of our conscious activities, but of those creative activities for which nature has endowed us with no effort of thought. The most important creative act for which nature has designed us is the begetting of children. And it is not a mere happy chance that that is an enjoyable activity. It could not be otherwise, in art or in science or in bed. It is not possible to conceive a universe in which important creative activities are not pleasurable. Science is a pleasurable activity to the good scientist; you must believe that. It could not be otherwise.

Nevertheless, many people do not find it as pleasurable to read a theorem as to read a poem. And I am speaking of people who are capable of reading and following both. They have been taught science at school, they have tried from time to time to keep up with it, but now they find that the processes of scientific reasoning do not engage their deep interest. They may still like to read about a new discovery, but they no longer follow how it was made.

"They no longer follow how it was made": that clause reveals to us how it happens that people who want to be interested in science find it dull. They gape at the discovery from the outside, and they may find it strange or marvelous, but their finding is passive; they do not enter and follow and relive the steps by which the new idea was created. But no creative work, in art or in science, truly exists for us unless we ourselves help to recreate it. That was the theme of the companion essay on the arts, and it is just as valid and as important for the sciences.

It is not possible to appreciate the deep conceptions that science has created, and the beautiful discoveries which express them, unless we do something to recreate them for ourselves. This is a

hard saying, but it is true. If a theorem in science seems dull to you, that is because you are not reading it with the same active sense of participation which you bring to the reading of a poem. No poem comes to you ready-made — you have to help to remake it for yourself; and no theorem comes to you ready-made either — you have to help to remake it for yourself.

Of course, it is hard to have to tell the layman that he will not find science interesting and pleasurable unless he himself brings something to it. "After all," says the layman, "I am trying to understand: and if the finished discoveries are all that I can understand, am I to be blamed? Is not science to be blamed for using a technical language in which I cannot hope to follow either the logical or the imaginative steps?"

These are reasonable questions, and they engage scientists as well as laymen. Every teacher of science knows that some of his students never learn the living language, but only the techniques, so that they never rediscover and remake the theorems for themselves — they only learn them by heart. In time, these plodding students will become the journeymen of science, competent in routine but quite unimaginative. Yet to the outside world, the journeyman scientists are models of thoroughness and accuracy, the very picture of science in the popular mind. The outside world knows the difference between a journalist and a poet, but it does not know the difference between a journeyman scientist and a genius. It calls a commonplace poet just what he is, commonplace; but a commonplace scientist is called a scientist, and perhaps the very epitome of scientists.

But deeper than this domestic quarrel lies the layman's problem: how can he succeed in catching and matching the imaginative content of a theorem, the creative steps in a discovery? How can he find pleasure where I have said it lies, in following these steps for himself, when he does not know the language in which they are argued? How can he, a mere layman, learn the inwardness, the overtones, the richness of the imagery of science?

The answer to these questions is best displayed in a practical example. But by way of preamble there is one general comment that I can make before I give examples; and it is this. Yes, the work

of recreating a theorem for oneself is taxing. And there are even scientists who shirk it — the journeymen of science who prefer to learn the theorem by rote. But then, there are journalists in literature, too, who are too harassed or too dull to recreate a poem for themselves, even when they admire it. They too find it easier to learn the poem by heart.

In the last essay, I illustrated the power of language to evoke many different responses by quoting a poem by Dylan Thomas. So it is appropriate that I should discuss our responses to the language of science by choosing as my practical example once again a poem. The poet is William Empson. He and I were students together at Cambridge in England at the end of the 1920s, during the remarkable time when physics was transformed by new discoveries and new theories in a few years. We were both students of mathematics, but we spent our leisure in editing together a literary magazine, one of the famous little magazines of the 1920s. The magazine was called *Experiment*, and that title itself says something about the way that we wanted, almost without thinking, to carry the language of science into literature. William Empson's poem is called "To an Old Lady." Like the poems by Dylan Thomas and Robert Frost, it is concerned with the process of growing old, and the hardening of human habit into elderly ritual. But Empson's imagery comes neither from nature nor from Hollywood. The main metaphor that runs all through the poem pictures the old lady first as living on another planet, and then as being herself another planet.

Ripeness is all; her in her cooling planet
Revere; do not presume to think her wasted.
Project her no projectile, plan nor man it;
Gods cool in turn, by the sun long outlasted.

Our earth alone given no name of god
Gives, too, no hold for such a leap to aid her;
Landing, you break some palace and seem odd;
Bees sting their need, the keeper's queen invader.

No, to your telescope; spy out the land;
Watch while her ritual is still to see,
Still stand her temples emptying in the sand
Whose waves o'erthrew their crumbled tracery;

Still stand uncalled-on her soul's appanage;
Much social detail whose successor fades,
Wit used to run a house and to play Bridge,
And tragic fervour, to dismiss her maids.
Years her precession do not throw from gear.
She reads a compass certain of her pole;
Confident, finds no confines on her sphere,
Whose failing crops are in her sole control.
Stars how much further from me fill my night,
Strange that she too should be inaccessible,
Who shares my sun. He curtains her from sight,
And but in darkness is she visible.

The poem describes a dignified old lady whose social life lies in a tradition which is dying. The literary echoes are evident: the first three words are quoted from *King Lear,* and the character and background of the old lady could come straight out of Osbert Sitwell's book *Before the Bombardment,* which describes just this kind of stately life in an English spa before the First World War.

But the vocabulary and the metaphors of the poem could not come either out of Shakespeare or out of Osbert Sitwell. The language is that of a scientific age, and indeed of a scientific mind. The old lady is pictured as fixed on a planet which is cooling and dying. We are not told what planet, but it is a planet with a godlike name: any planet, that is, except the earth. The old lady cannot be rescued by a rocket, and if a rocket arrived from the living earth, she would try to repel it, just as bees try to repel a new queen even when the hive needs one.

So we cannot rescue the old lady by a warm leap from the earth; we can only watch her through our spyglass. We can see her social nicety, playing bridge and running a house. We can observe how sure she is that she is traveling on the right path, and that her life is not narrow — it is what she wants to make it.

There are other solar systems, other civilizations: it is strange that the old lady, who lives in the same system of civilization as we do, should be so remote from us. But the fact is that, at most times, our vision of her is blinded by the superficial appearance of a common civilization, a common sun, that we share. In reality, what the old lady and we share hides the deep differences between us. Only when we forget what we have in common do we see her and her tradition as they really are.

Stars how much further from me fill my night,
Strange that she too should be inaccessible,
Who shares my sun. He curtains her from sight,
And but in darkness is she visible.

It is obvious that this poem does not wake in us the same swift, sensuous response that Dylan Thomas's poem wakes. Empson's poem sounds more awkward and at first leaves us cold. Yet it is also clear that, once we have walked through the reading as I have just done, if we run through the poem again we begin to grow warmer in the running. For example, the last verse grows richer and more emotive the second time round, as I have quoted it, when the prose meaning has been spelled out once.

All this is certainly not explained by saying that the language of science is unpoetic. That is another fallacy — the fallacy that in a poem you cannot say "telescope", but must say "optic tube," as John Milton did in *Paradise Lost*. William Empson says "telescope" and "compass" and "precession," and though these words sound technical the first time round, we soon get over that. After two or three readings, we understand the words for what they are: lively images that fit into and fill out the astronomical setting of the poem, and give it fresh overtones.

No, the difficulty of the poem lies not in the scientific words but in the scientific ideas. The stumbling block is the strangeness of the thought itself in places, which does not connect with any familiar thoughts, and so raises no echoes in our imagination. Let me take one precise line: we are told of the old lady that she, "Confident, finds no confines on her sphere." There is a small verbal play here between "confident" and "confines" which we can all catch. But the heart of the metaphor comes from mathematics: it is the theorem that a surface can be finite in extent and yet have no boundaries, no confines. The surface of a sphere (of a planet, for example) is of this kind: it is finite in extent, and yet if you or the old lady walk all over it you will never meet any boundary and will seem to be going on to infinity.

This is the language of science that most of us lack: not the technical words, but the simple basic ideas like the one that I have just explained. If Empson's poem fails to set us on fire, it is at these points, where we need to bring to it a grasp of the ideas from

which his metaphors reach out. The wealth of a language lies not in its words, but in the metaphors and associations which they stir in our minds. And these metaphors, these associations, are of ideas. If we fail to recreate it for ourselves, it is because we are not at home with the basic ideas on which it stands.

Many people think that the ideas of science are highly abstract, and can only be expressed in formal equations. That is yet another popular fallacy. At bottom, no fundamental ideas, in any subject, are abstract. The human mind works with images, and even its most subtle ideas have to be composed from images. We cannot form any theory to explain, say, the workings of nature without forming in our mind some pattern of movement, some arrangement and rearrangement of the units, which derives from our experience. (That is why, for example, the reasoning of physics is always arguing about waves and about particles, which derive directly from our physical experience.) In this sense, the whole of science is shot through and through with metaphors, which transfer and link one part of our experience to another, and find likenesses between the parts. All our ideas derive from and embody such metaphorical likenesses.

Once again, I shall give one example and treat it in detail. About the year 1929, when William Empson wrote the poem which I have quoted, the American astronomer Edwin Powell Hubble made an unexpected observation. He was observing, as others had done, the spectrum of distant galaxies of stars, in which there can be recognized the characteristic lines that announce the presence of some of the chemical elements that we know on earth — of hydrogen, for example, and potassium. It had been observed before Hubble that these characteristic lines, however, do not occupy exactly the same places in the spectrum from distant galaxies that they occupy in the spectrum here on earth. The lines are shifted, and most often they are shifted toward the red end of the spectrum: that had already been noticed. Now Hubble looked more closely at this general quirk and at once sharpened it. First, he found that (if the exceptions are properly analyzed) the lines are shifted toward the red, not in most but in fact in all distant

galaxies. And second, he found that the shift toward the red end of the spectrum is greater, the more distant the galaxy (if our guesses about their distances are properly linked together).

These, then, are the facts: the light from a distant galaxy looks redder, the farther away the galaxy is from us. But what do the facts mean? What cause underlies this universal shift toward the red end of the spectrum? In the first place, what can cause a characteristic line of hydrogen or of potassium to appear redder when it reaches us than (we assume) when it left the star in the distant galaxy?

You notice that I have already made an assumption, namely that a characteristic line of hydrogen or of potassium is really in the same place on the spectrum in any part of the universe. We do not know this; we have nothing but our experience on earth to guide us. And seven centuries ago, in the time of Thomas Aquinas, it would not have occurred to us that our experience on earth could be a fair guide to the heavenly bodies. Now we have reversed the assumptions of Aquinas, and we take it for granted that a star is made of the same stuff as the earth. What else can we assume? we ask. Yet that gigantic metaphor between earth and heaven, which is an invention of science, breaks with every picture of the past.

Very well: if the spectrum left a distant galaxy looking as it does on earth, what shifted it to the red on its journey? We cannot be certain. No theory of science is certain, for every theory is an imaginative extension of our experience into realms which we have not experienced. We shall never meet a distant star at first hand, in time or in space. But suppose that we assume, on other grounds, that light travels to us from a distant galaxy in the way in which a wave travels. Then it will follow that light will seem redder when it reaches us, that is, its wavelength will have lengthened, for the same reason that any other wavelength lengthens: because we and the galaxy are moving away from one another. An Austrian physicist, Christian Johann Doppler, hit on this idea more than a hundred years ago, when he noticed that the whistle of a train that is moving away from us sounds lower in pitch, that is, longer in wavelength, than that of a train that is still.

He took the leap from the world of sound to the airless world of light, a million times faster than sound; and we take the same leap, we make the same bold analogy, when we conclude that the reddening galaxy is flying away from us.

On these assumptions, then, on these hazardous extensions from our experience, the galaxies are all flying away from us. But that in itself is puzzling. Can the galaxies really be flying away from *us*? Can we really believe that we on earth occupy the unique unpopular spot in the universe? In the days of Aquinas, we should have answered Yes! with pride. Of course we on earth occupy a unique place, we would have boasted — even if it is uniquely unpopular. But first Copernicus and Giordano Bruno, and then the theory of relativity, changed all that. In science to-day, in the great vision of the universe, we no longer picture the earth to be at the center of things. Today we say that if the galaxies seem to be flying away from us, they must be doing something more universal: they must all be flying away from one another.

Yet this again is an extraordinary thought. Can we really understand, can we imagine, a universe in which every galaxy is moving away from every other? Can we conceive, that is, a universe which is expanding as a whole? What we are trying to picture here is the whole of space expanding — and yet not expanding *into* anything: simply expanding. A universe which is finite but unbounded, like the surface of a sphere, could do that. But it can do it in your imagination, you can recreate the thought in your mind, only if you are willing to understand what the surface of a sphere is like. Arthur Eddington and Albert Einstein took Hubble's idea on to this last splendid conception of an expanding but finite universe of relativity. And if that fires your imagination too, then there will fall into place with a triumphant sound the line from William Empson's poem "To an Old Lady": "Confident, finds no confines on her sphere."

I have given this full account of one modern theory in science for two reasons. First, in order to show that the ideas of science do embody a strong and strongly intertwined imagery, which can help us to recreate them for ourselves much as we recreate a poem or a painting. And second, in order that I may finally discuss one

remaining question about science and art which is constantly asked. The question is this. Must not a scientific theory be true, and may not a work of art be quite untrue?

The answer to this question turns, as once did the answer that Pontius Pilate gave, on the sense that we give to the word "true." In the popular mind, science is true because it counts, measures, and exactly describes the facts. But this definition of science is mistaken, and the meaning that it gives to scientific truth is a fallacy. A scientific theory, as I have just illustrated, is a much larger, more profound, and more intimately linked structure than this. Yes, the theory must conform to the facts, and must not fly in the face of the evidence of our senses — of the evidence, that is, of our own experience and the experience of people who do more delicate experiments in laboratories. But all that evidence, all those facts are only the cage and outer surface of the truth that the theory seeks to embody. Inside the cage of facts and evidence, the theory is a structure which we judge by its inner connections, its cohesion and coherence, and its ability to fit the facts with the most beautiful economy of ideas.

A theory does not simply state the facts: it shows them to flow from an inner order and imaginative arrangement of a few deep central concepts. That is the nature of a scientific theory, and that is why I have called it a creation of the human mind. Of course a good theory has practical consequences, and forecasts true results, which go beyond the facts from which it started. But these successful forecasts do not make the theory true — they only show that it was even wider than its creator supposed. Isaac Newton's theory of gravitation made wonderful and unexpected forecasts for two centuries after it was conceived; yet fifty years later, Einstein's theory of relativity showed that, in any obvious sense, Newton's theory had never been true. And fifty years from now, a new theory may show that Einstein's theory in turn had never been true. But to say this only makes it evident how foolish we would be to use the word "true" in this narrow sense about any theory. Newton and Einstein created marvelous and coherent and widely embracing visions of the natural world, which conformed to the facts as they knew them, and which threw a splendid but never a final light into the innermost structure of nature.

All created works, in science and in art, are extensions of our experience into new realms. All of them must conform both to the universal experience of mankind and to the private experiences of each man. The work of science or of art moves us profoundly, in mind and in emotion, when it matches our experience and at the same time points beyond it. This is the meaning of truth that art and science share; and it is more important than the differences in factual content which divide them.

I closed the first of these two companion essays with a poem, and I want to do that again. You will allow me, I hope, a small touch of vanity: this time, I shall quote a poem of my own. The theme of the poem is the connection between what happens to each of us individually and how the universe behaves as a whole. No one, says the poem, stands apart from the cosmic process as a whole; the great movements of the universe enter and extend into our most specific and individual acts. It happens that one of the images that runs through the poem is the shift of the spectrum of distant galaxies toward the red which I have described. And it happens also that the poem was written at Christmas, and came into my mind when, standing beside the tree, I saw the red veins in my hand like branches.

Faster than light and cold as absolute,
The edge of darkness races in pursuit
Of this expanding leaf, this Christmas tree
Of veins in which I hold the galaxy.
It is my hand, from which there streams and rips
The cosmic shift, red to the fingertips,
And what that flying shadow hunts is me.

Some astral bang, some primum mobile
Rocketed both of us, the headlong Bear
And me, into the incandescent air.
The motion that we share entails it all:
The virgin birth, the carol tune, the tall
Luminous star that prophesies — although
Its only secret is that children grow.

Faster than night and cold as Helium II,
The edge of shadow races to undo
The secret of creation, the abrupt
Choice of a womb or atom to erupt,
And what the flying darkness hunts is you.

THE SHAPE OF THINGS

Though I am a mathematician, I have been occupied for several years with the problems of aesthetics, and I shall begin by stating some of my principles. I do not regard aesthetics as a remote and abstract interest. My approach to aesthetics is not contemplative but active. I do not ask, "What is beauty?" or even, "How do we judge what is beautiful?" I ask as simply as I can, "What prompts men to make something which seems beautiful, to them or to others?"

This is a rational question and it deserves a rational answer. We must not retreat from it into vague intuitions, or sidestep it with hymns of praise to the mystical nature of beauty. I am not talking about mystics: I am talking about human beings who make things to use and to see. A rational aesthetic must start from the conviction that art (and science too) is a normal activity of human life.

All the way back to the cave paintings and the invention of the first stone tools, what moved men either to paint or to invent was an everyday impulse. But it was an impulse in the everyday of men, not of animals. Whether we search for the beginnings either of art or of science, we have to go to those faculties which are human and not animal faculties. Something happens on the tree of evolution between the big apes and ourselves which is bound up with the development of personality; and once our branch has sprung out, Raphael and Humphry Davy lie furled in the human beginning like the leaves in the bud. What the painter and the inventor were doing, right back in the cave, was unfolding the gift of intelligent action.

If I am to ask you to study this gift, I must point to some distinction between animal behavior and human behavior. One characteristic of animal behavior is that it is dominated by the physical presence of what the animal wants or fears. The mouse is dominated by the cat, the rabbit by the stoat; and equally, the hungry animal is dominated by the sight and smell of food, or of a mate, which make him blind to everything else present. A mastiff with food just outside his cage cannot tear himself away from the bars; the food fixes him, physically, by its closeness. Move the food a few feet away from the cage, and he feels released; he remembers that there is a door at the back of the cage, and now that he can take

his eyes off the food, away he races through the door and round to the front.

This and many other experiments make plain the compulsions which hold an animal. Even outside the clockwork of his instinctive actions, his needs fix and drive him so that he has no room for maneuvers. A main handicap in this, of course, is that the animal lacks any apparatus, such as human speech, by which he can bring to mind what is not present. Without speech, without a familiar symbolism, how can the mastiff's mind attend to the door behind him? His attention is free, his intelligence can maneuver, only within the few feet in which the food is not too close to the cage and is yet within range of sight or smell. Man has freed himself from this dominance in two steps. First, he can remember what is out of sight. The apparatus of speech allows him to recall what is absent, and to put it beside what is present; his field of action is larger because his mind holds more choices side by side. And second, the practice of speech allows man to become familiar with the absent situation, to handle and to explore it, and so at last to become agile in it and control it. To my mind, the cave painting as much as the chipped flint tool is an attempt to control the absent environment, and both are created in the same temper; they are exercises in freeing man from the mechanical drives of nature.

In these words, I have put the central concept of my aesthetic: evolution has had, for man, the direction of liberty. Of course men do at times act from necessity, as animals do. But we know them to be men when their actions have an untroubled liberty — when children play, when the young find a pleasure in abstract thought, when we weigh and choose between two ambitions. These are the human acts, and they are beautiful as a painting or an invention is beautiful, because the mind in them is free and exuberant. And you will now see why I framed my opening question so oddly; for it is not the thing done or made which is beautiful, but the doing. If we appreciate the thing, it is because we relive the heady freedom of making it. Beauty is the by-product of interest and pleasure in the choice of action.

These are the principles in which, I believe, an active and living aesthetic must be rooted. I have developed them once again, and

in detail, because I do not think that we can talk sensibly about practical design without them. Indeed, they have a special relevance to industrial design. The industrial processes have been the busy liberators of man in the last two hundred years. They have themselves sprung from a most human impulse — the impulse to use and, in order to use them, to make tools. Benjamin Franklin at the beginning of the Industrial Revolution called man the tool-making animal; and the modern tool, the machine, is a characteristic human invention. In turn, the machine gives man an enlargement of freedom, and that in two ways. It gives him the choice of making new things, and thereby it opens up new uses for the things he makes. The new machine or process, the new material, and the new use: each is a work of exploration, a feeling-out of the freedom which each creates.

Let me give a historical example. In 1779, John Wilkinson, with the help of another great ironmaster, Abraham Darby the younger, for the first time built a bridge of cast-iron parts, at the place which is still called Ironbridge in Shropshire. This may seem a modest technical advance. But in fact it was a break with the centuries of timber, of stone, and of brick — a breakthrough into a new dimension of the possible. It opened a new boldness in design; for example, the bridge had a semicircular arch. It invited new uses for the material, and in 1787 John Wilkinson launched the first boat made of iron. When he died in 1805, he had himself buried in an iron coffin.

Wilkinson's contemporaries felt, as I do, that the iron bridge was a true enlargement of human freedom. This is why of all men Tom Paine was enthusiastic for it. Paine had no interest in bridges for themselves. His interest was in American independence, in the coming French Revolution and its echoes in England, and in the Rights of Man. Yet, in these crises of liberty, Tom Paine found time to make and exhibit a model of an iron bridge for London; and this, for the same reason, is the same search to widen the human vision which might prompt him today to speak up for jet aircraft or the paintings of Georges Braque or the odder implications of quantum physics.

And the exploration of the bridge did not end with these pioneers. Kingdom Brunel designed the great suspension bridge

which now crosses the gorge at Clifton. In our century, a succession of bold thinkers have built new bridges, first in reinforced concrete and then in prestressed concrete. What they have made has been useful and beautiful together, an enrichment which step by step has opened the potential of nature to us — the potential of human use and the potential of human appreciation together.

There are people who acknowledge this physical expansion, but who refuse to see in it what I also stress, that growth of the mind and widening of appreciation have come with a scientific society. To them, the technician is a gadgeteer but not a liberator. He seems to them constantly to impose limitations on what they would like to believe possible. "You cannot do this with the material," the technical man seems always to be saying to them; or worse, "You must do that." They take a simple view of human life, and it is this: that the artist is indeed a liberator, but that the scientist more and more binds and constrains life. And lest you should think that this view is held only by dilettantes and by dealers in antiques, let me remind you rudely that it is the common view; it is indeed the commonplace view, which does duty for thought, and lightly springs to the lips, whenever a nonscientist today lays down the law about science.

It is of course true that the freedom which a new discovery brings is not boundless. Iron and concrete, steam and electricity, printing and television, each new potential has its limitations. But these limitations are not imposed by the scientist; they are *found* by him, and by the artist, slowly as they explore the virgin field. And neither can work in the new field alone. If the artist refuses to learn, in his own person, what the scientist is discovering about the materials in which he must work, then of course he will find these limitations a burden. And equally, if the scientist is too bigoted to feel himself into the sensibility and the living values of the artist, he will propose only dead structures. Both must share, both must enter into all the knowledge of their time. Knowledge which another man supplies is always a constraint; every addition to your own knowledge is a liberation.

The deepest change in the habits of Europe and America in the last hundred years has been made by the increasing use of elec-

tricity. The dynamo, the electric motor, the switch and the valve, the telephone and the thermostat, the vacuum cleaner and the refrigerator have changed our ways of living. The electric light has added to the life span and, yes, to the culture of Western peoples, simply because it has made their day longer. Can we really accept all these from the technician, and yet suppose that somehow he and the artist are at odds? Can we think that the designer is outraged by having to learn about voltage and the load factor, or humiliated by having to think of insulation? The very questions are nonsense. On the contrary, the coming of electricity has set some of the most interesting problems in domestic design, and because the artists who have solved them have taken pleasure even in the technical difficulties, they have done much to form the taste of our age.

I have glanced, with little patience, at the false opposition between the designer and the technician. This is the fallacy of the ivory tower: the notion that we live in a world whose measurements are inexorably fixed by science, and that the designer can do no more than languidly to embellish it here and there with a silk bow and a lily.

Nevertheless, this false answer does remind us that, behind it, there is a question. If the designer is not merely to decorate the thing made, what is he to do to it? Where is his place in the making of the thing? And if, as I have said, he must himself understand the techniques which go into it, how far do they fix what he is to do?

These are, in their different forms, the one fundamental question in industrial design. The object to be made is held in a triangle of forces. One of these is given by the tools and the processes which go to make it. The second is given by the materials from which it is to be made. And the third is given by the use to which the thing is to be put. If the designer has any freedom, it is within this triangle of forces or constraints. How should he use his freedom there?

There was a time when there was a ready-made answer to this question. Thirty years ago it was widely believed that, under a

careful scrutiny, the triangle would be found to have no area at all. The tools, the materials, and the use together were thought in themselves to imply and to fix the design. Let the designer steep himself in the industrial process, they said, and beautiful works will flow from his hands of themselves.

We have come to see then that this also is a fallacy: the triangle without freedom was the technician's fallacy, which I call the fallacy of the iron tower. Indeed, it is difficult now to understand how anyone could ever have been deceived by it. Here we live in a world in which a thousand daily objects surround and encumber us: the chair and the lamp, the book and the cigarette lighter, spectacles and keys, men's shoes and women's hats. In the bright variety of shapes in which these are used every day, could it ever have been sensible to suppose that each has a best form? Even so universal a thing as a bottle, or so specialized a thing as a watch, did not have a best design.

There is of course a truth hidden in the fallacy of the iron tower. It is a negative truth, and it is this: you cannot be certain how to design something well, but you can be certain how to design it badly. If you make a thing in a way which goes counter to the tools with which you make it, or counter to the use for which you make it, then you can be sure that what you make will be bad. This truth has a place, and industrial design has profited from it in the last thirty years. But it remains a negative truth; it says no more than that, if you make something which falls outside the triangle of forces, that thing will be bad; but within, alas, it will not necessarily be good. The triangle is not a point, and it does not help us to prefer one point in it, one acceptable design to another.

Nevertheless, there are some industries in which the tools, the materials, and the use come nearer to fixing the design than in most; and we should ponder what these industries are. The search for the principles of good design is bedeviled when it tries to range through all industries at once. For there is a difference between two kinds of industry — the traditional industries and the pioneer industries.

Consider the things, the simple household things, which have been pioneers in the last fifty years. I have already spoken of electrical equipment, all the way from the pocket torch to the refrigerator. Go on to the gas cooker and the controlled solid fuel cooker, to the mixer and the telephone, the radio and the television set. And beyond these, consider the things which have been at the head of technical progress: the motor car, the airplane, the calculating machine and the electronic devices which serve it.

It will strike you at once that these are the very things which are well designed today. The industries which make them are pioneers, making new things in new ways; and the new problem, the unheard-of adventure of flying through the air, influences design in two ways. First, of course, it liberates the designer from convention; and second, it comes nearest to determining of itself the logical structure and with it the shape of the thing made. This is why the pioneer industries are leaders in design: because we sense that the things they make conform not to history but to logic. And this has been so in the past whenever a new technical advance has been made; the slung carriage, the yacht, and the cooling tower imposed their own designs, and were beautiful in their day, exactly like the jet aircraft and the delta wing today.

Because the pioneer things interest and satisfy us, there grows from them a custom in the eye which forms our taste for other things. There is, for example, a good deal of banter about the word "streamline," and designers are asked why an electric iron should be made to look as if it could fly through the air. The streamlining of such things is, of course, an echo of functional design which was appropriate in airplanes and, rather less so, in motor cars, where it began. But streamlining is not necessarily inappropriate to stationary things, to which it extends the taste which has been trained elsewhere. We are now distressed by protruberances on an electric iron or a piece of furniture, not because we want either to fly through the air, but because machines that fly through the air have taught us to question the purpose of such decorations. In this way, the pioneer industries create a unity of appreciation, and bring home to us that no design can be

made or judged in isolation from others. The boldness which they teach becomes a model for all design.

Even the pioneer industries do not conform to the fallacy of the iron tower. There are many makes of motor cars; it is possible to make the most modern airplanes in a dozen shapes, all of them dazzlingly handsome. What is true, however, is that in the pioneer industries the technical needs determine the design more nearly than in others. The chief determinant in the traditional industries is history; but in the pioneer industries, the chief determinant is logic. Here the layout of the process and the mutual arrangement of the functions impose an order of their own, which makes some overriding demands of structure. The logical relations imply certain spatial relations: above all, they imply that the important element in the design shall be the shape.

We have grown used to the notion that what is to be designed is the shape of a thing, and it now seems to us self-evident. But it is, in fact, a revolutionary notion. The Victorian designer was not asked to shape things but to decorate them. Ours is not the first age to be preoccupied with shape, of course: the Greek sculptors were, and the Gothic masons. In recent history, however, the trend of art was away from the logic of structure in space, and we should recognize that our preoccupation with shape is a new and radical approach to the world about us that is not confined to industrial or, for that matter, to any other art. The streamlined iron and the Scandinavian chair are expressions and, more, are explorations of a universal interest in the shape of things, as much as the sculpture of Brancusi and Henry Moore. This new interest, and the shift from Victorian interests, is just as striking in the sciences.

For the sciences equally have changed their preoccupation. A hundred years ago, it was the pursuit and manipulation of exact measurements. The great advances in physics and chemistry in the nineteenth century rested on this, and so created the picture (it is still the popular picture) that science is wholly concerned with quantity. But the concern of science today is very different: it is with relation, with structure, and with shape.

Today we hardly ask how large space is, but whether it is open or closed on itself. We say that rubber stretches because its atoms are strung out in chains, and a diamond does not because the atoms are locked in a closed pattern of rings. We believe that the enzymes in the body fit the chemicals which they rebuild as a key fits a lock. And when we are asked why bacteria absorb the sulfa drug on which they cannot grow, we answer that the drug deceives them: its molecules have the same shape as the body chemical which the bacteria seek.

The most striking example of this geometrical way of thinking, as it were, is in the researches of the last years on the nature of life itself. How are living things able to reproduce themselves in exact copies? We have had our first inkling in recent work on the structure of the nucleic acids which are important in all living things. A molecule of a nucleic acid consists of a pair of spirals, each wound round the other and held to it by cross-links. If one spiral of a pair splits away from the other, it seems likely that new atoms can only join it at the links in such a way that they form a spiral of precisely the same kind. Thus the arrangement seems designed to reproduce itself, and we glimpse the reproductive process in the very shape of its parts.

These examples illustrate that in our society, we express logical relations as structure, and we express structure in shape. The interest of the industrial designer is part of the interest of our whole society, and, in the pioneer industries, he leads this interest. Such an interest is natural in an age of discovery, when new tools, new materials, and new uses crowd round us and carry us headlong to new ways of ordering our lives. Our age is, like all great ages, an age of transformation: this is why, like other great ages, we are still looking for our own taste, and will go on doing so until the great days are over. In an age of transformation, it is clearer than at other times that a sound aesthetic must grow from the actions that are practised and the things that are used, the characteristic actions and the new things, every day.

It is easy for us, living in this thought, to blame the Victorians for their indifference to aesthetics in the things they made. But of course the Victorian indifference *was* an aesthetic — a poor

aesthetic, but a positive one. Their furniture and hardware are often thought to have been bad because their taste in pictures was bad. This is not so; it is the other way about. The Victorian taste in pictures was debased because it was not founded on a bold and active taste in the things they made. The taste of an age is a unity, and if we want to avoid the monumental boredom of the Victorians in painting and literature, we must first avoid making mud huts in modern materials.

I should like to end with some reflections on the fine arts, and to do so I ought first to glance at the place of decoration in industrial art. After all that I have said, why do we take pleasure in the decoration of things, which adds nothing to their use? The engraved glass, the silver candlestick, the painted cart have already solved all their functional problems before they are engraved, chased, or painted. If the maker does not stop at the formal solution, it is because the very handling of the materials fills him with a desire for more. He is conquered by a sense of pleasure and of exuberance. The freedom which the materials give him makes him boldly stretch and reach; and his ease in them makes him, as it made the baroque architect, gay and extravagant. Each of us can picture this feeling best in his own profession, and since my profession is mathematics, I will sketch it for you there.

Mathematics is a language: the language in which in the first place we discuss those parts of the real world which can be described by numbers or by similar relations of order. But with the workaday business of translating the facts into this language there naturally goes, in those who are good at it, a pleasure in the activity itself. They find the language richer than its bare content; what is translated comes to mean less to them than the logic and the style of saying it; and from these overtones grows mathematics as a literature in its own right. Pure mathematics grows from what began as an application, just as good decoration may grow as a poetic projection of the object.

I am by temperament as well as by profession a pure mathematician. It is natural therefore that I like literature better than the newspapers, poetry better than prose, and the imaginative

film better than the documentary. To tell you the truth, I like pure art better than industrial art. But for just this reason, I am alive to the importance of applied mathematics and the newspaper, of prose and the documentary film and industrial art. No true appreciation of pure mathematics or of poetry can grow except from these strong roots. If you neglect the seed ground of a lively industrial art, then all art withers.

We can see these origins, I think, in modern painting. The rise of abstract painting is, of course, a part of the universal interest in structure and shape. Indeed, the phrase "significant form" was used by Clive Bell before abstract painting gained importance, when the main influence was that of the Impressionists. There are critics who believe that the appreciation of these forms is inborn in men, as a sensuous pleasure in abstract shape. I do not share this belief, which I think is contradicted by the art of many earlier ages. To my mind, pleasure in abstract structure is part of the thought of our age, as much as the scientific speculations which I have quoted. And the structures, the shapes which give us pleasure take their significance from our own experience: from the delta wing and the Meccano set, and from the biological research and our growing understanding of the patterns which make plants and animals work.

I have presented an active aesthetic, in which pure art grows from practical art, beauty from the pleasure in choice of action. To me, art and science belong to the everyday of human action, and are essentially human because they explore the freedom which man's intelligence constantly creates for him. Because ours is an industrial age, this freedom is expanding fast, in new tools, new materials, and new uses. The designer must understand their techniques at first hand, for they form the logic for his design. It is characteristic of our age that we express logic as structure, and structure in shape. This is striking in the designs in our pioneer industries, where logic comes nearest to fixing the shape, and which therefore form our taste. Yet even there the techniques do not wholly fix the design, because no design exists in isolation from others. There is a unity among the things we make, a unity of purpose and of action, which shapes their design toward the

image of an age. The practical artist expresses, and at his best he leads, the unification of our age, in which its growing points and its intellectual monuments become one. This is why I regard the work of the industrial artist highly and critically; why I see in his struggle with the shape of things the preoccupation of all thought today.

ARCHITECTURE AS A SCIENCE
AND ARCHITECTURE AS AN ART

I am not an architect, and I cannot instruct you either in the science of architecture or in its art. My title, then, is not meant to outline a teaching program in architecture. In choosing this subject and in thinking through it, my starting point has been the opposite; it has been an interest in science and in art. I read the title backwards, as it were — literally so, for I begin with art; this is, at bottom, to be an essay about aesthetics.

You may ask why, if I want to write about aesthetics, I should choose architecture as my ground rather than, say, painting. This is a serious question, and I do not want to balk it; but since it goes to the heart of the matter, the only answer is to unfold the whole matter. In the end, I must answer the question by developing the argument of this essay. I can make a start, however, by saying that it seems sensible to approach so abstract an inquiry as aesthetics in a practical context. That is, my approach to aesthetics is not contemplative but active. I do not ask, "What is beauty?" or even, "How do we judge what is beautiful?" I ask as simply as I can, "What prompts men to make something which seems beautiful, to them or to others?"

If we ask this question of the most primitive works of art we know, say of the cave paintings in Spain and France, we are told that the painters were making magic. In drawing these animals crossed with spears they were exercising some power over them and conjuring them in the hunt, much as the witch doctor enslaves a man by uttering his secret name. Perhaps the picture, like the name, or like the wax image, was the soul of the animal pinned to the wall. At any rate, it was a magic symbol; it had a purpose. We do not believe that man, any more than the bower bird, decorated himself or other things aimlessly.

I will accept the rather mixed evidence for this view; these hunting scenes, painted in black, inaccessible places in uninhabitable caves, had a purpose. They were prompted by a purpose; but I do not grant that the mystic purpose also gave them their bright, living form. The evidence of every cult is against that. The witch doctor does not conjure with a beautiful image; he conjures with a bag of bones and a shriveled fetus. Whatever pageantry sur-

rounds a magic rite, the charm which works the magic is brutal and ugly. In the Greek ceremonials, the dazzled worshiper at last found, in the holy of holies, a wooden stump or a rough-hewn stone. In all religions the hermit, the ascetic, the puritan visionary reject the beautiful because the intoxication of the mystery they seek comes to them from another, immediate union with the unknown.

If, then, the splendid cave paintings had a magic purpose, I do not believe that they were the center of the mystery. I do not believe in the mystic element in art. There has been, exceptionally, an artist here and there, and a scientist too, who has been a mystic by temperament: Michelangelo was one, and probably Faraday. But in general, what happens to an artist when he finds God is what happened to Botticelli when he joined Savonarola, or to that prodigy among thinkers, Pascal, when he repented of his youth. They cease to worship God in his creation, and struggle only for his presence.

I make this point forcibly now, at the outset, because it is central to my theme. Nothing but confusion and damage result if art is thought of as a mystic communion — even if, as is usual, the thought is shallow, and is meant only to stress the sentimental and the evocative elements in art. Art contains many elements, and mystery, sentiment, and evocation are certainly among them. But if we give them a commanding place, the result is disastrous: it is the posturing poetry of Tennyson, the nineties, and T. S. Eliot; Pre-Raphaelite painting and George Watts; and the kleptomaniac architecture of Alfred Waterhouse and Edwin Lutyens leading, inevitably, to the Tudor pub and the Alhambresque cinema.

The crux of a rational aesthetic is, I believe, the conviction that art (and science too) is a normal activity of human life. The painter in the cave was doing nothing more extraordinary when he painted than when he or another invented the spear; and both feats of the mind are as natural and, yes, as necessary to the rounding of a man as are loving and counting. Something happens on the tree of evolution between the big apes and ourselves which is bound up with the development of personality; and once

our branch has sprung out, Raphael and Humphry Davy lie furled in the human animal like the leaves in the bud. What the painter and the inventor were doing, right back in the cave, was unfolding the gift of intelligent action.

You will forgive me for still remaining far from architecture. My reason is that architecture is a complex art, one of the peaks in man's exploration of nature (including his own nature); and we must look for his drive to explore in simple things first. Florence in 1480 is a more interesting subject than the behavior of apes, but it is so precisely because Florence astonishes and perplexes us; and if we are to find a clue to her wonders, we must begin modestly at actions which we understand.

One characteristic of animal behavior is that it is dominated by the physical presence of what is wanted or feared. The mouse is dominated by the cat, the rabbit by the stoat; and equally, the hungry animal is dominated by the sight and smell of food, or of a mate, which often makes him blind to everything else then present. A mastiff with food just outside his cage cannot tear himself away from the bars; the food fixes him, physically, by its closeness. Move the food a few feet away from the cage, and he feels released; he remembers at once that there is a door at the back of the cage, and now that he can take his eyes off the food, away he races through the door and round to the front of the bars for it.

This and many other experiments make plain the compulsions which hold an animal. Even outside the clockwork of his instinctive actions, his needs fix and drive him so that he cannot free his mind for maneuvers; in the close presence of his desires, he has no liberty. At the same time, the animal is handicapped by lack of an apparatus, such as human speech, for bringing to mind what is not present. The mastiff's area of intelligent maneuvering is, as it were, the few feet that are not too close to the cage and are yet within range of sight or smell.

This is where man as we know him has always lived in another world — a world with an added dimension of freedom. He could do two things. He could recall the hunted animal when it was absent; and he could use this gift to make the animal's presence familiar, so that somehow he exorcised the compulsions which

otherwise dominated him in that presence. To my mind, the spear and the cave paintings are both created in the same temper: they are exercises in freeing man from the mechanical drives of nature.

In these words, I have put the central concept of my aesthetic. It goes back to the view that evolution has had, for man, the direction of liberty. When he must act, as animals do, from necessity, his actions are satisfying and no more. But when he moves into his own domain of liberty, then, like the swimmer racing in the sun or the man whistling at his carpentry, what he chooses to do is an exercise of pleasure, and is beautiful. It is the human act within the cave paintings which still makes them beautiful to us. And you will now see why I framed my opening question so oddly; for it is not the thing done or made which is beautiful, but the doing. If we appreciate the thing, it is because we relive the heady freedom of making it. Beauty is the by-product of interest and pleasure in the choice of action.

Every great movement in art has this stamp, that it is a breaking through, a breaking out into liberty. The Renaissance is the shining example, when men burst the rigid forms of thought which had long held them fixed and made an art in which every glance is an adventure. The writers of Queen Elizabeth's last years live visibly in a world of discovery and widening humanity. The special tone of the works of Christopher Wren and John Vanbrugh, at once bold and self-contained, draws from their liberation from two opposing tyrannies — the Stuart and the Puritan. And the Romantic Revival has written its own manifestos to freedom, in Rousseau and in Wordsworth's Preface to the *Lyrical Ballads*.

These examples remind us that what inspires the artists of an age is also the high inspiration of their society. The Renaissance, the reign of Elizabeth, the Restoration, and the Romantic Revival are not private incidents in the history of art. They are also the times of scientific discovery, of economic expansion, of conquest, and of new political thought. Yet none of these is the effect of another; art and science and politics and the rest, they are all original. The movement to freedom which springs in them all is not a mechanical result of this or that technical innovation. It is a

human movement, straining in every age to free itself from the compulsions of the past, and breaking out whenever discovery or imagination opens a first crack in the rigid shell of society.

It is sometimes said that our age will never form a taste, because it is bent on appreciating the tastes of all ages, and on finding African sculpture as expressive as St. Peter's. I am not sure whether factually this is as evident as André Malraux claims: there is art (Augustan and Victorian for example) which we find as uncouth as the Augustans found Chaucer and Shakespeare. But where the stricture is true, it is because the center of gravity of appreciation has shifted. In spite of appearances, we are not trying to see Sta. Sophia and Chartres and the work of Borromini and Gropius all as equally beautiful. We are trying to see them as equally expressive; we are trying to find in each of them the stretch of freedom, the muscle at play, which expresses the men and the time that made them. Our appreciation is directed by the sense of history felt as human development, and we take pleasure in all these constructions because we relive and take part in the act of making them.

Yet I am troubled in moving to these historical examples, because it is easy to lose in their large textbook manifestos the exact sense of freedom which my aesthetic demands. When I say that Leonardo in his drawings freed himself from the hierarchic thought of the Middle Ages, I do not mean that he deliberately became a rebel, a scientist, a skeptic, a homosexual. Leonardo was all these (he was left-handed and illegitimate too), and they are certainly facets of a single uncompromising personality. But the freedom I catch in the drawings has not at all this truculent air. The drawings are the work of a happy man, who turns over and over in the pleasure of what he does, because his skill has been set free from the fixity of a conventional vision. And like the cave paintings, Leonardo's drawings play with a gesture again and again, as it were to explore the boundaries of freedom. So the bear cub and the running hare play in the moments when they are free from the compulsive patterns of action, and in playing discover the limits of their own capacity. The games of children and men are such happy exercises in freedom.

For liberty is not a passport to chaos. When men break one restraint they do not, as its defenders always fear, enter a limitless tohubohu of free verse and free love. The new art, the new science, is not absolutely open; it has its own necessities, and its first task is to find them. Often the new art is so solemn about this that, like Le Corbusier's designs, it begins by looking more puritan than the manner which it exploded.

The drawings of Leonardo patently have an ease which the Bayeux tapestry lacks. Yet of the two, Leonardo in some ways had to hold within stricter limits; for example, he had to draw in the newly discovered perspective; and he was himself busy in setting limits to what was allowable as representation, by his own work in anatomy and on aerial perspective. In a sense, Leonardo and the Renaissance painters were more scrupulous than those of the Middle Ages.

Of course their scruples were of a different kind: they were scruples of artistic, not of moral, conscience. They did not prejudge the artist's (or the scientist's) task, as the Middle Ages did; they discovered it. But scruples and boundaries there always are, to every gain in intellectual freedom. There is nothing contradictory in this, and it does not make discovery pointless. On the contrary, the physical ease which modern science has added to our daily lives proves over again the lesson of Leonardo: that the more precisely we learn the limits which nature has set, the greater our confidence and with it our liberty of action within them. Freedom is not a denial of nature (as medieval magic thought) but her exploration.

This, then, is the duality which gives tension and structure to my aesthetic: for if there were no duality, there would be no field for aesthetic judgment. On the one side is the movement of our evolution, away from compulsive action and toward a widening freedom; this is each man's wish to choose his own acts, and thereby to become a person. And on the other side are the limitations which, ridge beyond ridge, reappear to constrain and in a sense to sustain us: the state of human thought at any time, the boundaries of what has been discovered, our contagious anxieties, the rigors of convention and of social institutions. Each of

the great intellectual revolutions has broken through these at its time, and swum into a new sea of freedom in art, science, and society together. But beyond each isthmus there is another; each sea in turn is landlocked; there are natural limits to action in the new age too. The pride of the best men is to probe for these limits by the adventure of their work. These are the pioneering minds, who press forward in the new freedom and create those works which, in exploring it, discover (because they reach) the new frontiers. Lincoln Cathedral is such a creation, and Alberti's Rimini, the craft of Dürer and Grinling Gibbons and Wedgwood, the Circus in Bath and the Crystal Palace. And equally the plays of Christopher Marlowe and Newton's *Principia*, Coleridge and Cézanne and Rutherford, all stretch out and fill the freedom they themselves created, to its limits. The new age ends only when these limits in their turn become fixed and conventional, and wait to be cracked by another discovery toward the next freedom.

I hope that it is now becoming clear of itself why I chose to present this theory of aesthetics in the context of architecture. For I know no other work of man which is so profoundly a balance — no, a fusion — of freedom and necessity. The task of the architect is to design a shelter, as the task of the locksmith is to fasten it; and both are contained by the materials which they can use. Yet architecture has evolved for this circumscribed task a bold and rich imagination, refreshed in each change of society, of which no other craft has a hint. The buildings of the great designers arch out of their materials as spontaneously as a fountain.

Think back through the revolutions in architecture. Gothic in France in the twelfth century begins at once with the rib-vault and the buttress, and for three hundred years is a constant play in the freedom (and the limitations) which these engineering devices give. They are means which, as it were, open space vertically; when that no longer yielded anything new, the Renaissance suddenly abandoned it and opened the space horizontally. The building in which Brunelleschi made this pioneer change in 1419, the Foundling Hospital in Florence, is to me still the most beautiful in the world.

A horizontal building (if I may describe architecture in my own way) is not held to a single line of sight, and must therefore guide our attention by its organization of detail. For me, this articulation of parts, this search for organic structure, runs through the Renaissance. It floods into Baroque and exhausts itself there, because it had reached the limits of what seventeenth-century materials could sustain — what would Balthasar Neumann have given for steel joists and prestressed concrete!

The next revolution begins at a new problem: domestic needs in the climate of Paris and further north. It comes to life, I think, in the work of Christopher Wren at Oxford and Cambridge, and of his colleague Robert Hooke in the rebuilding of London after the fire. What is best in the eighteenth century stems from their invention; moreover, Wren's bold, almost impertinent conceptions (the place of the lantern on the Sheldonian, for instance) have a kinship with those casual, peremptory innovations of iron and glass which stand alone in the architecture of the nineteenth century.

I want to stop at Christopher Wren and Robert Hooke, however, because they give flesh, symbolically, to an issue which is central to architecture now, and indeed to our culture. Neither was trained as an architect. This of course was not new; none of the pioneers of the Renaissance was an architect either. Brunelleschi was a goldsmith, Bramante was a painter, and even later Bernini was a sculptor and Inigo Jones a designer for the stage. They were, however, professional artists; but Wren and Hooke were not even that. Both were by profession scientists, and were at the center of scientific life. It was at the end of a lecture on astronomy by Wren on 28 November 1660 that the Royal Society was founded, and Hooke became responsible for the experiments at its meetings soon after. Twenty-four years later, amid their building plans, Wren was still arguing with Hooke about science, and the outcome of one dispute was that they sent Edmund Halley off to Cambridge to ask Newton a critical question on gravitation. Newton had worked out the answer years before, but when Halley arrived he could not put his hand on it. He began to write it out afresh, and ended by writing the *Principia*.

I quote these incidents in order to make clear that Wren and Hooke were not minor figures; in the age of greatest scientific speculation before our own, their minds marched with the leaders. Hooke's neglected reputation in science is now reviving, but he remains unlucky in his architectural work because hardly any of it has survived; or if it has, like the Monument (which he built), it does not go by his name. These two springing minds rebuilt London. Was their architecture original because they were scientists, or in spite of it?

This is the type of question which now troubles all serious artists. The easy answer is to give science a sort of kitchen maid's place: in architecture, to let her supply the materials and techniques, and to begin the creative work only when the skeleton has been fixed by some handbook engineer armed with the codes of practice. Gilbert Scott put this view baldly when he said that "architecture is decoration of construction," and his own work is a noisy witness to the consequences of this definition of architecture as schizophrenia. But the view (and its disasters) has not died with Gilbert Scott.

On this mistaken view, science is thought to fix what I called the limits or constraints within which art works; and art is the defiant gesture of freedom, pinning plaster rosettes to the building in spite of the engineer. Science is thought at work from year to year, calculating the right stresses and dimensions for a building more closely, until one day it will have narrowed the tolerances to nothing at all. The building will be determined by calculation; nothing any longer will be open to choice, and therefore freedom and with it art will be at an end.

No one can hold this foolish view while he is standing in front of a building by Wren or his associates. On the contrary, in them the new knowledge of mechanics was plainly a liberation of imagination, and not a restriction. In what way, then, is this plausible interpretation of my aesthetic at fault?

Its grave fault is that it pictures art and science, not merely as different skills, but as different tempers, which must inhabit different men. From the moment that the architect consents to take the structural engineering from someone else, his building is

doomed. There are no composite works of art, not even in the cave paintings or the ballads; you can no more make a building in which someone else (a man or a textbook) puts the joists than you can write a poem and have someone else put in the rhymes. For knowledge which another man supplies is always a constraint; but every addition to your own knowledge is a liberation.

Every building is an invention, no less and no more. It begins with a problem, which has nothing to do with the look, the construction, or the layout of the building, but asks something more searching: how should the activity which the building is to house be carried out? If the architect is not asked to help think this out, he will build what Britain is now full of: office blocks which are (I know no exception) meaningless rows of holes linked by tunnels; power stations and town halls which are indistinguishable; and vistas of semidetached houses which (though they may be poured in concrete or assembled from panels) differ from their Victorian models only because it is now too dear to dig out a basement. Ride the lifts in Broadcasting House, go to bed in any hospital, drop in to a prefabricated postwar villa for tea, and ask yourself whether the architect was consulted on how the work there could be made to flow.

He was not; but then, has he earned the right to be consulted? England is already building the world's first atomic power stations, and the designs which have been published show that they pose many exciting problems. Alas, the designs also show that once again they have been solved in the conventions of Battersea and Western Avenue. But what architect today knows enough science to be able to think himself into the new processes, and invent an organic plan? Wren and Hooke would not have muffed this chance.

Or take a simpler contemporary issue: the housing estate. The main problem in house bulding in England is the mass production of subunits. What architect has studied this at first hand where it has been solved, in the component and subassembly factories of the Detroit automobile industry? What young architect has fitted himself by research to tackle the central heating of the small house? or that other weak unit, the water and waste system?

The health — yes, the beauty — of architecture hangs on seeing that profession in this way. Architecture is not decoration, and it is not a jigsaw of technical tricks. A building is not a beautiful shell, and neither is it a functional shed. A building is the coherent solution of a problem in living. In that profound sense, a building is an invention, and all architecture is invention. Some of the most original architecture today is surely in Italian dams, in Swiss bridges, and in oddities like the Dome of Discovery. Wren and Hooke would have delighted in these problems; and like them, the architect must fit himself for solving all parts of the work in his own person. His invention is only free when it rises out of his own scientific as strongly as out of his artistic imagination.

What I have been putting to you is the central issue of our age. We all hanker for beauty expressed as freedom of choice, because freedom (this is the crux of my aesthetic) is an emotional need as real as the physical need for rest, comfort, and gadgets. We all fear and feel the constriction of a uniform society and a threatening world. This tension is as old as man, and gives his thought its spring, its creative invention, in art and science together.

But now our generation has begun to make a dangerous distinction: it has separated these two modes of original thought, and identified art with freedom and science with its inevitable limitations. This identification is false, as I have shown in architecture. It is unhealthy for the artist, because it makes him narrow and the public taste narrow — but, alas, a century apart. It is bad for the scientist, whom it makes dictatorial, irresponsible, and philistine. And it is a disaster for mankind.

For a society is as balanced as a building is. We must not fall into the trap of parceling out either between two minds: between the architect and the engineer, or between the statesman and the scientist. The statesman cannot create a policy if he simply accepts the sanctions from the nuclear physicist. Statesmanship without scientific vision, even citizenship without it, is (like bad architecture) a mere decoration of acquiescence.

The danger is that we take our positive policy from the past, and use modern science only negatively to protect that. This

would indeed debase science from an instrument of personal freedom into an obstacle. And this abuse faces us with physical destruction and, what is as threatening, with a moral revulsion against science throughout the West. Our populations have begun to fear science instead of learning it; if this goes on, we are doomed. For societies are not bound to go forward, from freedom to greater freedom. Greece fell, and Rome, and the world was a darker place for at least a thousand years. God has not insured civilization against the fear of his gift of reason.

We can heal these divisions only in creative work: taking pleasure in our freedom and exploring it to its limits. In our age, we have not begun to reach these limits, and certainly they are not set by science. On the contrary, the constraints which we accept are still the conventions of the past, dead styles and ancient policies. Everything new that we learn, in science as in art, gives us confidence and freedom to break through these constraints. But we have to learn it for ourselves, in our own person and experience. You cannot sustain a civilization vicariously by calling in Lord Cherwell on difficult days and Graham Sutherland on birthdays.

In the intellectual revolutions of the past, architecture has been a point of fusion: the most sensitive point at which new ideas in science and a new conception of the arts have crossed and influenced one another. Men have learned both, unconsciously, from the daily sight of great buildings. Today the architect bears the same responsibility for making science as well as art visible and familiar, and for having each influence and enter into the other. Architecture remains the crossroads of new science and new art. If the architect is willing to make them one, by learning to live naturally in both, there will at last be fine modern buildings, and citizens wise enough to see that they survive.

ART AS A MODE OF KNOWLEDGE

The A. W. Mellon Lectures in Fine Arts for 1969
National Gallery of Art
Washington, D.C.

1
THE POWER OF ARTIFACTS

I ought to begin this, the first of a series of six lectures, by saying something about my subject in general. And I will do so by drawing your attention to my use of the word "knowledge" in the title of the series. The arts have been described in many different ways, but it is not usual to think of them as either expressing or as transmitting human knowledge. Yet I propose to say in these lectures that the arts are a most important carrier of knowledge, and, in particular, that we derive from them an insight into human experience, and through that into human values, which to my mind makes this one of the fundamental modes of human knowledge. In short, my use of that word in the title is not an accident, but the gist of what I propose to say and develop in the lectures that follow. But it is clear equally that if art is a mode of knowledge, then I cannot be using the word "knowledge" in the sense in which it is ordinarily used in textbooks. Evidently, whatever knowledge art carries is not a form of instruction in the sense in which the knowledge that we gain from science is meant to instruct.

There are two things about scientific knowledge which leap at once to the mind. One is that it is predictive. When we have discovered and then taught some piece of scientific knowledge, we are able to look into the future with a clear-cut anticipation which has the character of a prediction. When Newton said that all massive bodies attract one another in proportion to the product of their masses and in inverse proportion to the square of the distance between them, he was not merely describing events. On the contrary, that had already been done by Kepler and Galileo. He was saying something which could conceivably be used in order to predict the behavior of yet undiscovered bodies. And secondly, the knowledge which science formalizes has in an obvious sense a very practical application — by which I mean that we can test it in practice, we can submit massive bodies to the predictions which Newton made and experiment to prove those predictions right. And more, we can then guide our conduct by these predictions. In that sense, scientific knowledge has the obvious features that it is predictive and practical.

Now, in some sense I hold that this is true of *all* knowledge. And I shall show you in time that the mode of knowledge which the arts carry is in many respects similar. We also learn in some way to take a predictive view of future experience, and of how people will act within their value systems. In the arts, these features derive from an underlying structure different from that of scientific knowledge, and it will be the aim of these lectures to define the structure of knowledge (as I use that word) which underlies the arts. However, at this stage I am more anxious to point out sharp likenesses and sharp differences which we will refine later.

In one way scientific knowledge is wholly different, in my view, from the knowledge which I shall characterize as being carried by the arts. Science offers explanations. I hold that the work of art carries a kind of knowledge which is not explanatory. I will linger for a moment on the word "explanation," and I will go back to the example of Newton. When Newton produced the formula about the inverse squares, it was not plucked out of a clear sky or out of laboratory experiments. It was, in fact, at that time not susceptible to direct test at all. The law of inverse squares was produced as an explanation of why the planets obeyed the laws which Kepler had discovered and published eighty and seventy years before in 1609 and 1619. The law of inverse squares struck Newton's contemporaries as a blinding flash of enlightenment. Remember the couplet in Pope's *Epitaphs*:

Nature and Nature's laws lay hid in night:
God said, *Let Newton be!* and all was light.

Pope meant by that not light in the sense that we can look out of the window and see the eastern sky glowing with red. He meant light in the sense that suddenly the disorder of nature (and even the order which Kepler had stated) was seen to be the outcome of a deeper level of explanation. Kepler's declaration that every planet moves in such a way that it sweeps out in equal times equal areas of the ellipse it describes around the sun as one of its foci is a statement of what, for convenience, we will call observable fact, even though the mode of observation was remote. But when Newton said that this and the other two laws were the direct out-

come of the law of inverse squares, he effected a unity whose character was explanatory.

The knowledge that science carries, then, is always an explanation. The explanations change with the rolling on of the centuries. We no longer think that the motion of the planets is explained by Newton's laws, but by more delicate and sophisticated laws which Einstein proposed more recently. And yet one reason why we do not despise Newton and say about him, "Silly old man, he just got it all wrong; it took another couple of hundred years before anybody got the right idea," is that it is the nature of explanation to have an inherent intellectual interest, and to generate a profound intellectual pleasure, even when it becomes something of a museum exhibit. And in some sense one may think of the great discoveries in the way of knowledge and explanation that were made in the past as having the same status as the pictures in a great gallery, which no one would think of painting that way today and yet which are what Yeats in "Sailing to Byzantium," called "monuments of unageing intellect."

I shall propose in the fullness of time a definition of knowledge suitable to the arts which *is* different. But at this moment what I want to say is that though science and art share in their modes of knowledge something of predictive and something of practical value, yet the mode of knowledge of science is different in that it is explanatory. In my view, art carries knowledge, profound knowledge. We learn from it, above all, during youth; but what it offers as knowledge in the end is not explanations.

Having given you this broad view of my subject, let me now pause for a little time longer on my own interests. What I have said is patently the result of an interest in science and in the arts. I speak as a professional scientist and only as an amateur in the arts, though I propose to use the word "amateur" in its literal sense as "a somewhat inexperienced lover." You must expect from me a good deal of scientific example and scientific discussion. But not much of it will be concerned with Newton, Kepler, and physics, because during my own lifetime my interest has shifted toward more biological sciences and, in particular, to

what makes human beings what they are. I call my subject by a title which I have invented myself, namely, *human specificity*. Of all the species of animals, human beings are a very special species. And it is the characterization of the human species, the characterization of what makes human beings specific, with which I am most concerned.

Now there are a great many things which make human beings like other animals — particularly like the mammals, of course, and like the primates to which family they belong. And a good deal of popular literature (and indeed of scientific literature) has been preoccupied in recent years with explaining to us why at bottom human beings are only a kind of animal. Of course, it would be a very poor lookout if we were all angels. It is of the greatest importance that we should think of ourselves as sharing many animal instincts, as taking pleasure in many animal activities, and that we should not think of the monuments of the spirit as being divorced from that solid, animal basis on which our instincts and impulses undoubtedly rest. But when that has been said, it is to my mind essential to add, Alright, I have heard about that, I have heard about the drive to aggression, I have heard about the territorial imperative, and I understand that I share the one with the "Tyger" and the other with the "Robin Red breast." However, it is an evident fact that the tiger and the robin redbreast do not lecture about us, whereas I am at this moment talking about them. And that is a distinction which we must not overlook if we are really going to talk about human activities.

My accent then is on those things which have got human beings where they are. And among those things language, reasoning, imagination, and their expressions in science and in art are cardinal. It is right that we should remember that two million years ago there was nothing much resembling human beings anywhere in the world. There was no point in talking about Rembrandts or the poems of T. S. Eliot, because nothing that could conceivably be thought of as a creature capable of either recreating or appreciating those existed. Moreover it is right to think that in the enormous perspective of geology and evolution, we have come to where we are in an incredibly short time. In something between a

million and half a million years we have been promoted to the status that we now occupy. It is that status which makes it possible to talk either about science or about art. And when I speak from time to time of the wonderful knowledge about specific human evolution (most of which has only been unearthed in the last twenty years), it will be always with an eye to this central theme: Why is it that we as human beings naturally express ourselves in creative discovery — creative discovery in the sense of science; creative enlightenment in the sense of art?

Through all the human cultures that we know, one thread runs continuously, and it is made up of two strands. That thread is the thread of science and of art. We know no culture — however primitive by our standards — which does not in some form practise the kind of explanation which I have called science, and in some form practise what we shall be talking about, art, both visual art and art expressed in verses, riddles, epigrams, and the like. This indissoluble pairing surely expresses an essential unity in the evolved human mind. It cannot be an accident that there are no cultures devoted to science which have no art, and no cultures devoted to the arts which have no science. And certainly no culture is devoid of both. There must be something deeply embedded in the human mind — specifically in the human imagination — which expresses itself naturally in any social culture both in science and in art.

The characteristic feature of all human cultures is that they make artifacts; and this is really what we mean when we say that the human mind is creative. That is why I have called this first lecture "The Power of Artifacts." Human beings are not unique in making artifacts. The finches of the Galapagos Islands which Charles Darwin visited on the *Beagle* do pluck thorns in order to get at insects under the bark of trees, because having been born finches and having decided to behave like woodpeckers, they require some artifact to get under the bark. Similar behavior can be found in some other animals and, of course, most expressively in the most intelligent of all animals, the chimpanzee, who uses sticks in order to fish ants and termites out of the ground, uses leaves in order to sop up water and then squeeze it into his mouth,

and gives other evidence of using made objects — artifacts. But those rudimentary beginnings bear almost no resemblance to the artifacts with which we have surrounded ourselves, almost from the time that human evolution took off. That is why it has been only in recent years that they have been recognized as artifacts among the animals.

From the very beginning of specifically human evolution we have made tools or artifacts to serve our purposes. The very first caves and heaps of rubble in Africa which display fossil evidence that looks to be on the road to modern man, and is perhaps two million years old, already has associated with it pebbles which do not come from the site in which they are found, but have been brought from a river bed a mile or two away. The presence of these pebbles illustrates in itself a kind of foresight which is absent in other animals. Even when the primitive hominid has only brought these and stored them, he is already taking a look into the future which, on the whole, is obscured from other animals. And when we find the first chipped and shaped tools, which are certainly several hundred thousand years old, we know that now man is at work. And when we find the first tools which have been stored because they are good for chipping and shaping other tools, we realize that we are practically on the road to modern production methods.

Now artifacts have, as I have suggested in my title, a very special power. But before I go on to explain that special power, let me say that the purpose of this lecture is to make you conscious of the continuous line that the artifact follows from its earliest beginnings in chipped stones to the most splendid buildings today. It is because the man who chipped the stone as it were unfolded from it a design that was not there, but that he *put* there because he exploited the nature of the stone and his own invention at the same time, that he opened the path to what we know today. And I mean the path to what we know both in the work of science and in the work of art, for the work of art is one ultimate achievement along the line that begins from the primitive stone tool. Some years ago I spent a Christmas in India, and there I was very struck both by the primitive stone tools that one could find and by the

prodigious stone carvings in the rock temples which less than a million years later and less than two thousand years ago from us, already manifested this miraculous ability to use the stone to make a work of art. And the thing that struck me about both of these extremes was the way in which the primitive stone unfolds the plan which is then the central creation of the human intellect.

Since I know much more about poetry than about the visual arts, I shall in these lectures frequently use poems for illustration. And I have allowed myself the small vanity of beginning with a short Christmas poem that I wrote myself when I was in India, which illustrates my point about the inherence of all human creativity in the primitive artifact. (The poem supposes that one of the Magi came from India to Bethlehem.)

One of the magi brought, to match
The lapis lazuli, a flint:
Folded like a child, the print
Of man slept in the artifact.

So in the caves of India bloom
The convoluted hands of gods
Waiting till the millennium nods
To burst the blueprint from the womb.

The lights along the Ganges run
From Christmas to the fingertips,
And monuments and weather-ships
Articulate the same design

That prophetic man began
When from the stone he chipped the plan.

The characteristic feature of all human cultures is that they make artifacts; and this is really what we mean when we say that the human mind is creative. The artifacts begin as simple stone tools, some of which are at the least several hundred thousand years old. What characterizes these and later artifacts is the double message that we read in them all, from the first chipped piece of stone: that tells us what they are for and also, at the same time, how they were made. So the artifact is an invention which carries its own blueprint with it — as we look at it, we see forward into its use and backward into its manufacture, and it extends our culture in both senses. This double power of the artifact inheres in every-

thing that has been made all through history and up to the present.

But it is time that I discussed some specific artifacts. The marvelous stone cleaver or ax in figure 1 is a comparatively well-made object of its kind. It is about a hundred thousand years old, and it is by no means one of the oldest or one of the most primitive artifacts. I begin with it in order to show you vividly how an artifact reveals what it is the moment you look at it. And even the man of a hundred thousand years ago who picked it up must have realized at once when he held it in his hand that the cutting edge at the top of the picture is for cleaving or cutting. But the whole structure shows how it was made — how you can make such an object for yourself if no one has shown you how. And this sense of both What is it for? and What is the blueprint for it? runs through all of the objects that I am going to discuss.

The lintel of the grave of Shebna Yahn (figure 2), not far from Jerusalem, is about three thousand years old. I chose it because it shows signs of very marked sophistication. (Of course, it should; three thousand years is not a long time.) But notice the way a vertical is supposed to fit into the dowl; notice also the lettering, because we must remember that speech and writing (the poem, the manuscript) are also human artifacts and have the same sense of looking both forward and back.

A detail of skilled laborers from a stained glass window at Chartres is shown in figure 3. I chose it to show that a certain reverence for the man who makes things is evident in medieval churches, that they are not devoted solely to saints and to contemplation. The wheelwright on the left of the picture and the man with the hammer on the right are engaged in everyday activities of which, of course, a very high opinion was held in the Middle Ages; witness the fact that we still use the word "mason" to mean something more than just a man who knows how to handle stone.

The mechanism of Pascal's adding machine of 1642 (figure 4) takes us forward rather rapidly to the first calculating machine, which the young Pascal built for his father. And you can see that wheels can be put to a different use, to a different plan. Moreover,

you only have to look at it to realize that although it is called a calculating machine, it is really just a series of wheels held together in the same way as the mileage register on an automobile.

And here, indeed, is the automobile itself (figure 5). I could not resist this Model T Ford when I was looking for expressive artifacts. And if you are in any doubt about what I have said (the fact that you really know how to make it once you look at it), well, there it is, any teenager could build the whole thing from that picture.

I am going to quote extensively from Blake because I know his poetry best. And so I have chosen an illuminated page from one of his books, the title page of *America* (figure 6). This is the artifact — the made thing, the created thing — in a different context. It is only a sense of mischief which has made me choose one called *America, A Prophecy.*

Next is part of the typescript of T.S. Eliot's "The Waste Land."* It has some marginal notes by Eliot and some marginal notes by Ezra Pound. It is the passage now called "A Game of Chess," which starts with the crib out of *Antony and Cleopatra:*

The Chair she sat in, like a burnished throne,
Glowed on the marble, . . .

Again, what has prompted me to choose it is the sense that in looking at that page, you have both a poem and the making of a poem.

And finally I have chosen a gorgeous goddess from the Tanjore district in southern India (figure 7). Her name is Nataraja and her function is to have many hands — "the convoluted hands of gods."

The importance of the artifact in human history lies in the fact that to the man who has made it, it is only a thing which has a use (even though the use may be as obscure, as in the case of the poem by T. S. Eliot). But to the man who sees it, it also tells the story of how it was made. In that way the artifact makes us able to share

*[This figure was not available for reproduction in this volume. — *Ed.*]

not only the vision of the maker about what he wanted to do with the object but also his experience of creation in making it that way.

It is an important part of what I have to say — and have indeed said in the first chapter of *Science and Human Values* and elsewhere — that the work of art is not something that you can look at passively. It must move you to pose two different questions. One is, What was he trying to do? And the other is, Why did he do it that way? Now I hold that those two aspects of the work of art — the poem, the painting, the piece of sculpture, the piece of architecture — are already present in the earliest artifact. Human beings have been able to develop their cultures at a prodigious rate exactly because everything that they have made has carried this double question, and with it a double explanation.

You can think of the first of these questions in the work of art as having to do with the *content,* and the second of these questions as having to do with the *style.* But, as I shall say repeatedly, in my opinion those things are not separable, because unless the style means to you that that is how the content has to be put, you have not begun to recreate the work of art. You are only in the pathetic situation of those elderly friends of mine who look at a picture and say, "My little boy could do as well as that." Or conversely, of those equally pathetic young friends of mine who look at a picture and say, "My daddy would paint like that," which is the modern counterpiece, the pop art counterpiece, to the old jibe about the Picassos that everybody's little boy could paint. To say that this could be done by somebody without experience, without knowledge, without any of the training and trusteeship in the arts which have gone into the work is merely a betrayal of bottomless ignorance because it is a complete failure to recreate the work as if you were the artist. It is a failure to look at the stone ax and say not only, "I see what it is for," but also, "I see how it was done." And that means why it was done that way. And it is equally a failure to carry that forward into the poem and into the painting and say, "Yes, I see what it is trying to say, but why did he choose this way of saying it?" And until you have answered that question, you have not recreated the work, and no work speaks to you until you recreate it.

No work gives you more than a journalistic summary of itself until you have also recreated it from the question, "Yes, I see what he was trying to do, but why did he try to do it that way?" I close this first lecture with a poem which says this with extraordinary clarity. It is a poem by William Blake from the *Songs of Experience* called "The Tyger." I want you to think of the poem in this way: that Blake is thinking of God as a creator, a maker of artifacts. The tiger is his creation. And what Blake is asking of that artist, God, is, How did He come to make the tiger? I can see what the tiger is for, but why did He make the tiger like this? Read in this way, the poem conveys more vividly than any words of mine the way a great artist himself thinks of the work of someone he regards as a still greater artist, namely God:

Tyger! Tyger! burning bright
In the forests of the night,
What immortal hand or eye
Could frame thy fearful symmetry?

In what distant deeps or skies
Burnt the fire of thine eyes?
On what wings dare he aspire?
What the hand dare sieze the fire?

And what shoulder, & what art,
Could twist the sinews of thy heart?
And when thy heart began to beat,
What dread hand? & what dread feet?

What the hammer? what the chain?
In what furnace was thy brain?
What the anvil? what dread grasp
Dare its deadly terrors clasp?

When the stars threw down their spears,
And water'd heaven with their tears,
Did he smile his work to see?
Did he who made the Lamb make thee?

Tyger! Tyger! burning bright
In the forests of the night,
What immortal hand or eye
Dare frame thy fearful symmetry?

The poem really ends not with the last verse (which is a refrain), but with the verse before. This is the question that Blake was putting directly to God, but in a more profound sense to the whole universe: Why the Tyger if the Lamb (particularly the Lamb with

its Christian overtones)? I shall come back to the poem in a later lecture, but at this point it seems to me the right note on which to recapitulate this central question: What is the artifact, what is the work of art, saying? And why has it been made in that way?

Did he smile his work to see?
Did he who made the Lamb make thee?

2

Lintel of the tomb of Shebna Yahn, Jerusalem, 700 B.C. The inscription, in archaic Hebrew characters, reads "This is the tomb of Shebna Yahn, attendant of the royal house. There is neither gold nor silver here. Cursed be he who opens it." Reproduced by courtesy of the Trustees of the British Museum.

1

Acheulian cleaver (flint hand axe) from the Somme Valley, Cagny, Route de Boves, France. Peabody Museum, Harvard University. Photograph by Hillel Burger.

3
Detail of a thirteenth-century
stained-glass window at
Chartres cathedral showing a
wheelright and a cooper.
Photographie Giraudon.

4
Pascal's adding machine, in-
vented when he was nineteen.
The "Pascaline" has a series of
wheels that shift digits from
one to the next; it can add, sub-
tract, multiply, and divide.
Erich Lessing, Magnum
Photos.

5

The 1925 Model T Ford. Ford
Motor Company.

6
The title page of Blake's
America, A Prophecy (1793).

7
Nataraja (Lord of the Dance),
Tamelnadic, Tanjore district,
thirteenth century (copper,
22.2 cm high). Pan Asian Col-
lection, Los Angeles County
Museum of Art.

2
THE SPEAKING EYE,
THE VISIONARY EAR

In my first lecture I said that in all human activity — scientific and artistic — the product is an artifact. The nature of human creation is to create things which bear the imprint of having been made. Artifacts have a peculiar power: as soon as you see them, as soon as you hold in your hand a shaped stone, a drawing, or an electric shaver, two things are apparent to you: on the one hand you see what it is for, and on the other hand (and more surprising) you see how it was made. It is this second point about the artifact which I think has made it such a powerful force in human evolution. It is not only that the artifact tells you what you should do with it — the shovel, the book — but also by looking at it you get a clear imprint of its own history. And that imprint in fact serves you as a blueprint for making it over again. That is the double power of artifacts. The work of art — the poem, the painting, the building, or the piece of sculpture — is an artifact in the same sense; it also has a double power. And this unity between what later I shall call *content* and *style* is an important theme of these lectures, and a crucial property of the work of art.

The title of this second lecture is "The Speaking Eye, the Visionary Ear." And naturally I chose that rather outrageous title in order to jar you into the appreciation of its theme, which is that the eye and the ear are intimately concerned in all works of art. It is not true that only the eye sees and imagines; it is not true that only the ear hears, or only the mouth speaks. On the contrary, my title is intended to draw attention to the unity of the imagination as it is expressed both in the visual arts and in poetry.

There are two plain reasons for talking in one breath both about painting and about poetry. In the first place, if one wishes to present, as I do, a unitary theory of the arts, one can hardly avoid confronting those that speak to the eye with those that speak to the ear. But there is a second and more searching reason which is contained in my title. I want to say positively that literature in general and poetry in particular are not simply made of words but operate with images quite as characteristically as does painting.

I shall start with an artifact from my first lecture. I used as an illustration the corrected, scribbled-over, criticized text of the section of T. S. Eliot's "The Waste Land" called "A Game of Chess." Here are the opening lines:

The Chair she sat in, like a burnished throne,
Glowed on the marble, where the glass
Held up by standards wrought with fruited vines
From which a golden Cupidon peeped out
(Another hid his eyes behind his wing)
Doubled the flames of sevenbranched candelabra
Reflecting light upon the table as
The glitter of her jewels rose to meet it,
From satin cases poured in rich profusion.

I chose this passage because the visual quality in it is very clear. On the other hand, if all poetry sounded like that all the time, nobody could bear reading many pages of it. It is obviously a highly decorated piece of verse, and nothing in the movement of the pictures in itself appears to have much to do with what poetry is about. In fact, the pieces about the jewels in it are an obvious echo of a famous scene from Alexander Pope's "The Rape of the Lock" in which a girl at the toilet table is described in a similar way. What Eliot is doing is rewriting the following kind of passage (the girl is being looked after by her maid):

Unnumber'd treasures ope at once, and here
The various off'rings of the world appear;
From each she nicely culls with curious toil,
And decks the Goddess with the glitt'ring spoil.
This casket India's glowing gems unlocks,
And all Arabia breathes from yonder box.
The Tortoise here and Elephant unite,
Transform'd to combs, the speckled, and the white.
Here files of pins extend their shining rows,
Puffs, Powders, Patches, Bibles, Billet-doux.

It is just as well to remember that poetry is at times written like that, but that this is not what poetry is really about. If this is what poetry were really about, then we could say, in rough measure, that prose was black and white and poetry was the same material colored. As we say in England, "Penny plain, twopence colored." These highly colorful passages have a place in the poem, but it is an extremely artificial place, and this is not the nature of imagery in the sense in which I want to stress it.

Indeed, I will pause for a moment at the word "colored" for this reason: the passage that I have quoted from Pope from which Eliot took some of his images has, as you notice, a very visual, colorful glow; the tortoise shell, the ivory, each made into a comb,

"the speckled, and the white." And that is a very curious phe-
nomenon in poetry of the early eighteenth century. Isaac Newton
had just published the *Optics*, and there was a great outburst of
interest in spectral colors. Pope uses three or four times as many
different color words as had Shakespeare, and he uses them
about ten times as often. And that, you see, tells its own story
because we do not think of Pope as a colorful poet. We do think of
Shakespeare as a colorful poet. That shows in itself that it is not
the "twopence colored" that makes the difference. For instance,
let me take one of Shakespeare's great instant images out of *The
Winter's Tale:*

 Daffodils,
That come before the Swallow dares, and take
The windes of March with beauty.

We remember Wordsworth's "host of golden daffodils" and we
expect Shakespeare's at least to be yellow. That is not what
Shakespeare says. They "come before the Swallow dares" (that is
the strong image) and "take the windes of March with beauty."

Now let me take you to the passage from Shakespeare's *Antony
and Cleopatra* describing Cleopatra's progress down the Nile
(which Eliot echoes in the lines quoted above):

The Barge she sat in, like a burnisht Throne
Burnt on the water: the Poope was beaten Gold,
Purple the Sailes: and so perfumed that
The Windes were Loue-sicke with them;
 the Owers were Siluer,
Which to the tune of Flutes kept stroke, and made
The water which they beate, to follow faster;
As amorous of their strokes.

So far we are still in this universe of highly decorated description.
But just as the power of the earlier image that I quoted from
Shakespeare lies in something quite different, so it is the next two
lines which in fact have gone into everybody's speech:

. . . the Owers were Siluer,
Which to the tune of Flutes kept stroke, and made
The water which they beate, to follow faster;
As amorous of their strokes. For her owne person,
It beggerd all discription.

"It beggerd all discription" is the one phrase out of this speech in *Antony and Cleopatra* which everybody knows, everybody uses, and which, indeed, few people could ascribe to this particular, otherwise highly colorful passage. The image is in the word "beggar." It is not in the highly colorful word; it is in the word which suddenly brings home to you a juxtaposition of two ideas — the idea of this enormously rich description suddenly being brought bluntly up against the simple fact that as to her person, "It beggerd all discription."

The point, then, that I have made so far is that the visual element of poetry does occur in gorgeous passages like that. And yet in some way it is not the most telling imagery. The poem and the work of literature in general must depend visually on something else. I say "visually" because, of course, I think that words like "before the Swallow dares," words like "It beggerd all discription," are visual. Remember Blake, "The Beggar's Rags, fluttering in Air." Words like these are visual, and yet the quality which we catch from them has a much deeper significance than merely what a beggar looks like or what the swallow looks like.

Now let me take a much simpler and more direct poem which again I have chosen intentionally because the thing that strikes one first about it is its high color value. This is a poem by D. H. Lawrence, written sometime between 1910 and 1925. It is called "Morning Work":

A gang of labourers on the piled wet timber
That shines blood-red beside the railway siding
Seem to be making out of the blue of the morning
Something faery and fine, the shuttles sliding,

The red-gold spools of their hands and their faces swinging
Hither and thither across the high crystalline frame
Of day: trolls at the cave of ringing cerulean mining
And laughing with labour, living their work like a game.

This is an interesting poem for a variety of reasons. One of them is this strange fondness that Lawrence had all his life for the notion that labor would become dignified, provided it was widely associated with the color red; there is a long and, I must say, rather boring chapter in *Lady Chatterly's Lover* in which it is explained that miners would be happy and would work well if they all wore

red trousers. (The trousers, of course, go with the book; but the red goes with Lawrence's general attitude.)

But notice that there is an extraordinary image working behind this coloring. This is a powerful small poem; it makes exactly the kind of point that I have made about artifacts and particularly about the satisfaction that people get out of their work. There are two things behind it. In the first place the color is not there simply as description; the color imagery is supposed to give you the idea that the laborers are enjoying their work. The other point of the poem is very strange: the words "shuttles," "spools," and "frame" are intended to make the labor appear like the labor of spinning. Lawrence is describing some people working on a railway siding in images which, in fact, come out of factory work — out of the spinning mill. And, looking below the surface of the poem, that is the juxtaposition which says that it is not just a matter of being out in the open, it is not just a matter of the fact that it was raining yesterday, that everything is looking very fine and fresh, it is also crucial that what the men are making is a human construct and gives them pleasure.

The word that I am going to use for all juxtapositions of this kind is the word "image." Indeed, at the very time that Lawrence was writing there was a school of poets who called themselves imagists. The theme that I have opened is that poetry is written not just in words and even visually not just in colors and not just in descriptions, but in images. It is therefore timely to ask something about the image in the human mind. And I shall begin with a brief description of the human imagination.

I use the word "imagination" to mean quite simply the manipulation by a human being of images inside his head. These images seldom have, for most people who use them, an intense visual quality. There are people who do, in fact, have highly developed *visual* imagery. That is, there are people who when they think, say, of President Eisenhower will instantly conjure in their minds a picture of what he looks like. To them the use of that phrase "President Eisenhower" of itself brings the visual image to mind. Such people often can turn the image round in their head quite literally.

However, that is not the most important thing for which we use the imagination. Most of the time we manipulate the image not in that rather trivial way, but by putting it into different situations.

People who see the image very vividly often have it in an even stronger form. Accounts of how Blake saw angels, how in his old age he drew people who were not present in the room, always describe the curious fact that when he drew somebody who was not present, he did so *as if* they were present. This is a very curious psychological gift; children have it quite often but most people lose it in adult life, and it is called *eidetic imagery*. And people who have eidetic imagery tend to see the image as if it were outside their head. And therefore they follow the movement, follow its outline with their eye, as Blake did. If you talk to them about a bicycle, you can literally see their eyes moving; or if you talk to them about a tennis match, you can virtually follow it in the movement of their eyeballs.

But those of us who do not have visual imagery in either of these vivid senses still carry on our lives by the use of images. This is the crucial human gift, and it begins with our ability to conjure up to the mind past events. Let me show you what I mean. Just over fifty years ago a man called Walter Hunter carried out a series of experiments in which he tested animals of different kinds in order to see how long they could remember an object which had been signaled and which was now removed. It does not much matter what animal you take, providing you do not go as high on the scale as monkeys. Almost any mammal will behave in the following situation in the same way. You present the animal with three alternative doors; over one of these doors you put on a light; the animal learns to run to the door which has a light over it, he finds it open, he finds a reward when he goes through it. If he goes through either of the doors which has no light, he gets no reward and he cannot get out. And in those circumstances, of course, he learns very quickly. Pavlov had recently published his first great papers, and everybody was full of this kind of Pavlovian experiment.

But Hunter had the idea of doing something a little more far-seeing. When the animal had learned without fail to go to the door

with a light over it in order to get out and find a reward, Hunter put on the light but held the animal. Then he put out the light, and he waited to see how long it would be before the animal forgot to go to the right door. Now you are all free to make your own guess on this, and you can all choose as intelligent an animal as you like, including your own dog or your own cat, provided you do not go as high up as the monkeys. And you will be surprised to hear that in that situation, given a choice of three doors, very few animals are able to remember where the light went on for longer than ten seconds. There are some exceptions, but it is always a matter of seconds, or at most minutes, until you get up to animals like monkeys. Now, of course, that is a completely different world from our world of memory. Hunter very wisely at the same time did the same experiments with some children of two, three, and four years old. He would turn on the light over one of the three doors, and then he would engage them in conversation. Since the children remembered where the light had been for a very long time, the conversations became very long and wearisome. And one little girl said to him at the end of about half an hour, "You know, if you do not stop chattering, I shall forget where the light was."

Now this difference is spectacular — though I should tell you that some of Hunter's animals were quite clever at circumventing his guile. Dogs, for instance (on whom in any case the experiment is not very fair because sight is not their main sense), could learn to outwit Hunter to some extent. When the light went on, a dog would turn himself toward the light and wait. And if he could only occupy that position for long enough, then when he was released he would be successful. Hunter, I imagine, thought this rather a low trick, but then every dog has a right to his day, too. I think that the dog was demonstrating something terribly important, which is that if you do not have a language, if you do not have any way of saying, "It is the left door or right door or the middle door," if you do not have any way of giving numbers to the door and saying "It is number 1, 2, or 3," what are you going to do? The world in that case is a rather dim arrangement of things which are not clearly separate objects. And unless you fix your-

self, unless, as it were, you translate your gesture into a word, symbol, or image, what else are you to do? Personally, I think the dogs came off best in the experiment.

However, it must be admitted that as soon as you get to animals with a well-developed forebrain, well-developed frontal lobes, like the little monkeys, their performance is out of all proportion better. The first gift of human imagination, then, is the ability so to recall the past that it has a visual or symbolic impact. It is with this ability that the imagination works. When we look forward, what we do is to rearrange in our minds the images of past experience and project them into hypothetical situations. And we do that just as much in writing a letter or in planning for next week's lecture as in an experiment, a poem, a work of art. Most of our lives are spent in inventing hypothetical situations, and asking ourselves which of these we prefer. "If I wear that dress tomorrow, will it be clean for the party on Thursday?" Now the point is that to the best of our knowledge and the available experimental evidence, there is nothing in the animal brain which corresponds to the ability to ask such questions. The whole manipulation of "tomorrow," "What shall I do?" "What will happen on Thursday?" "What will I need for Thursday?" — all that is an interior manipulation of images on which human foresight depends and which begins in the hindsight which is the human form of memory.

I have continued to use the word "image" although, of course, most of us do not use visual images for that kind of speculation. The images that we use most of the time — the symbolic units that we use — are words. But the mental ability from which they come is exactly that of an interior manipulation into hypothetical situations. D. H. Lawrence's description of the workmen, his finding a likeness to weaving, is a manipulation of this kind.

The power of human memory no longer strikes us as forcibly today as it did in the Renaissance, because we now have all sorts of mechanical aids for remembering, from shorthand to magnetic tape. But in the years between 1400 and 1600 there was a tremendous interest in human memory exactly because the recording of

things was a difficult, time-consuming process. (The printed book only appeared about 1450.) And one of the constant themes in the literature of the Renaissance is the magic of memory. There is, indeed, every reason to say that the particular power of manipulating images in hypothetical situations is a piece of magic.

At any rate, many Renaissance thinkers believed that the imagination was essentially magical. And since magic was an extremely forbidding and forbidden subject, there was a great deal of argument about whether it might or might not be employed. Spells were forms of words which were thought to be ejected from the imagination and literally to form themselves as solid things. It was quite common to write (even at a time when the subject was already rather advanced) that a great crowd of people could sometimes see the apparition of a saint because the great power of imagination of the preacher took the spiritous air which was already thickened and so shaped it that people actually saw the hidden saint.

It would be delightful to spend more time on this extraordinary period, but let me end with one more reference to it. Half way through the period 1400 to 1600 came the Reformation, and with it a great many Protestant thinkers who were extremely antimagic, indeed antiritualist, and who even denied the reality of transsubstantiation. In 1571 Thomas Erastus wrote, "Certainly no one in their right mind will think that an image fashioned in the spirit of my fantasy can go out of my brain and get into the head of another man." The interesting thing is that if Erastus, in this down-to-earth, antimystical passage, were right, then really both human speech and language, and all human communication, ought to be impossible, because he makes it clear that nothing that comes out of me ought to influence anybody else. But that is exactly what human intercourse does. The gift of imagination is that twofold movement by which it both manipulates images in my head and sets them spinning with a kind of communicative force which recreates them in yours, whether I am looking at a work of art, reading a poem, or talking about a theorem. Indeed what is certainly true is that all important human work in the arts

and in science consists exactly in fashioning in one's head a hypothetical situation which can overleap the intervening space and be reformed in the head of somebody else.

It has always been a great problem why images have this particular symbolic power. To this nobody knows the answer. All human speech is a mystery; but it is certain that it is joined in the evolution of the human brain to the development of the visual areas. We have a far finer visual discrimination than any other animal, even the chimpanzee. And the visual centers (the visual cortex) lie close to the aural centers. Where we hear and speak and where we see are closely conjoined areas which have developed together. And, of course, the speech areas in human beings are quite unique — there is nothing like them in any animal. I want, however, to close not with this peculiar human power of speech in itself, but with some of the images that have exercised great symbolic power, in poetry and art; and to make the point that these are, to my mind, indissolubly joined.

I chose the marvelous sphinx (figure 8) to remind you that the juxtaposition of man and animal is also part of literature — in this case, part of the Oedipus legend — and says something about how we think of ourselves as animal and man together which occurs both in the visual and in the spoken symbol.

And just so that you should not think that these symbols are the monopoly of what we call "the West," look at the bronze from South India of the god Ganesa with an elephant head (figure 9). He also has double features. (He has certain other advantages like several hands, you notice. I must say, a trunk, breasts, and several hands seem to be an amount of equipment that is more than sufficient for any person's needs!)

I chose the Byzantine mosaic of the star of Bethlehem (figure 10) not merely for all the beautiful details (including, note again, the angels — the human animal creatures), but because of the star itself, which also has had a very peculiar power, visually and symbolically, through all our history.

Monet's *Rouen Cathedral, West Facade* (figure 11) illustrates what I said earlier about poetry. But it is meant to remind you particu-

larly that the visual image has a poetic power just as much as the poem depends on the visual image. No one, I think, can look at this picture without having the feeling that something is being said about the emotional and poetic unity between ourselves and the construction — particularly when we compare it with Monet's other pictures painted at different times of the day.

And to bring that illustration up to date, I have chosen four towers from that marvelous unfinished Sagrada Familia cathedral at Barcelona that Antonio Gaudí began to build (figure 12). It is a superb example of an essentially poetic construction used to express the human spirit.

The design on the back of Leonardo's *Ginevra de' Benci* (figure 13) has, of course, definite emblematic meaning — the two wreaths and the branch in between say something about the provenance of the painting, for whom it was done, and so on. But the pleasure which Leonardo evidently took in this (we would have thought) almost irrelevant detail, this small signature, expresses his relation both to nature and to the symbol.

All the Paul Gauguin pictures have a tremendously poetic literary quality. I chose his *Fatata te Miti* (figure 14) because it is not only a splendid painting but also a highly literary work in the sense that all the things in it, although they do not come out of any familiar mythology, carry a highly emblematic quality for us. We recognize this as being in some way the imagery of an earthly paradise. I want to say that with a great force because people often assume that poetry ought not to paint pictures, and pictures ought not to be poetic. I say, on the contrary, that that, even if it were desirable, is simply impossible. It is the nature of images that they say something more than what they represent. And the whole history of these people in Gauguin's picture speaks of what I have called "an earthly paradise" without using any of the familiar Old Testament symbols.

Plate 32 from *Milton* by William Blake (figure 15) brings us back to the symbol of the star again. The star this time is Milton. Blake visualizes the Milton star of inspiration entering his foot as in some Byzantine fables. (Incidentally, those curious pants that he is wearing are, in my private opinion, not painted by Blake. I be-

lieve the book passed into the possession of Tatham who in his old age is known to have destroyed some of Blake's pictures because he thought they had a sexual connotation. And here I suspect that he painted those drawers on himself, because he did not want to destroy the picture. But that is a somewhat unorthodox commentary on that picture.)

I have ranged rather widely here over questions of the imagination, both in the purely biological sense and in the sense in which we meet it in poetry, the sense in which we meet it in the arts. I have wanted to put these together because I shall be talking at great length about what one really does in the work of literature and in the poem.

You see, until recently painting was comparatively simple: it was supposed to be a likeness. When it stopped being a likeness about a hundred years ago, we invented all sorts of other theories, starting from the Impressionists. But there was a long period before that during which you could easily grasp from the painting that this was what the artist was trying to do. Literature ceased to fulfill that function long before. It was already in some trouble four hundred years ago when people were talking about magical qualities. If, therefore, we are going to ask with any force, What is the knowledge that we get out of literature? Do we have any right to call it knowledge, and if it is not knowledge, why are we reading it at all? we have to ask ourselves in what particular way the imagination passes from person to person — never mind what Erastus said. What is the man trying to say? Why is he saying it as he does? What is Blake trying to say with the picture? Why does he choose this way of saying it? Why does the star I showed you speak to us?

There is a delightful essay by Baudelaire about Edgar Allan Poe in which he says of Poe that his imagination was a quasi-divine quality in which the intricate and secret relations of things, the correspondences and analogies, were depicted. It is as well to quote Baudelaire because I have used the word "image" to mean also a kind of symbol, and after all Baudelaire and his colleagues chose to call themselves symbolists. Baudelaire writes in a famous letter, "I have been saying for a long time that the poet is

intelligent par excellence, and that imagination is the most scientific of faculties because it alone understands universal analogy or that which a mystic religion calls 'correspondence.' " Now that I do not quite believe, and that is why I juxtaposed a picture which uses a well-established symbol like the star with a Gauguin picture which gives us all the same feeling of a highly symbolic situation without using any "universal" western symbols at all.

In the end, we come to the point at which we realize that the quality of symbolic and conceptual thinking of which human beings are capable, and which is mediated by the frontal lobes which begin with little monkeys — that quality combines two extraordinary human gifts: the gift of the eye and the gift of the ear. We use the eye most of the time in order to get information about the natural world; we use the ear most of the time in order to get experience of people. There is a little poem by Burns which will illustrate my point:

O, my Luve's like a red red rose
That's newly sprung in June:
O, my Luve's like the melodie
That's sweetly play'd in tune.

You notice that the rose part of it is essentially what his love looks like, but the tune part of it is "sweetly," and that is what describes her nature. We learn most about people through the ear. We learn most about nature through the eye. Indeed, the only thing I must add as a biological footnote to Burns is that, as a matter of fact, it is unlikely that we hear music with the same ear with which we hear speech. That seems an odd thing to say, but owing to the way that the brain is divided, and the fact that most of us have the speech areas on the left side of the brain, there seems to be some good experimental evidence over the last ten years that we preferentially listen to speech with the right ear and to all other noises with the left ear in order to conduct them to those corresponding parts of the brain.

Sight and sound, image and word are thus essentially wedded in a kind of emblematic symbol. And much of what I will have to say about the nature of literature in general, and poetry in particular, will deal with this emblematic quality which the images of poetry carry to us.

8
Head of the Sphinx of Hat-
shepsut (red granite), Dynasty
XVIII, Thebes. The Metropoli-
tan Museum of Art, Museum
Excavations, 1922–1923,
1926–1928.

9
Dancing Ganesa, Bengal,
tenth or eleventh century
(black basalt, 95.2 cm high).
Pan Asian Collection, Los
Angeles County Museum of
Art.

10
Nativity, Martorana Church, Palermo, mosaic. SCALA/ Editorial Photocolor Archives.

11
Rouen Cathedral, West Facade,
Claude Monet. Chester Dale
Collection, National Gallery of
Art, Washington, D.C.

12
Towers of the Sagrada Familia,
Barcelona, Antonio Gaudí.
Editorial Photocolor Archives.

13
Design from the back of
Ginevra de' Benci, Leonardo da
Vinci. Ailsa Mellon Bruce
Fund, National Gallery of Art,
Washington, D.C.

14
Fatata te Miti [By the sea], Paul Gauguin. Chester Dale Collection, National Gallery of Art, Washington, D.C.

15
Plate 32 from *Milton* by William Blake (London, 1804?). Rosenwald Collection, Library of Congress.

3
MUSIC, METAPHOR, AND MEANING

I come now to the crucial subject in any deep understanding of the arts: the relation of style to content. Critics of music, of painting, and of literature have always paid a great deal of attention to this, though it is only in the last twenty years that it has become clear how very crucial this subject is to what I will call "the human situation." Having a style is essentially a human thing. And in this respect we differ quite strikingly from the animals. I said in my first lecture that my own interest and passion is human specificity. And it is very specific to human beings that they have the ability to do things in a highly individual way.

I have laid some stress on how human beings make artifacts. Well, some animals make artifacts, too. There is a gorgeous bird, the bower bird, whose courtship ceremonial consists in building what is called a bower (and that is where the bird gets its name) to which the male invites the female and which the male decorates with stones and feathers and little objects that he finds, mostly of a very blue color. Now we do not know enough about the style of the bower birds to be able to say whether one can tell the work of one bower bird from that of another. But it would be surprising if one could; it would certainly be uncharacteristic of the way most birds make most of the things that they do. Birds make artifacts — they make nests. And a robin's nest is quite different from a thrush's nest. But so far as we are concerned, we can tell a robin's nest from a thrush's nest, but we could not possibly tell the nest of one robin from that of another. We certainly could not say, "Oh, this family of robins builds in this particular way." Because they do not. They have no characteristic architectural style.

From that analogy to the visual arts let me move on to the language, or communication, of animals. Now, if you go fairly high up in animal species to the primates (that is, monkeys and apes), you find that they have quite an elaborate vocabulary. A rhesus monkey has a vocabulary of somewhere between forty and a hundred sounds and gestures which are understood by the other members of the tribe. They all have the same vocabulary; nobody knows more words than anybody else. But what is most to the point, nobody uses the words in any different way. A very searching study of this subject has been made by the Russian Nikolay

94
Music, Metaphor, and Meaning

Zhinkin, who studied the language of baboons. They do not have a very large register, but they really make a very exciting series of grunts and barks and so on, and the arrangements of these have a meaning. Professor Zhinkin spent a great deal of time in learning the meaning, because he was very anxious to prove that if you were a baboon, you might be able to say the same thing in two different ways. Alas, a very elaborate and beautiful study finished up by showing that if you were a baboon, whatever you had to say could be said in one way only. That is equivalent to saying that baboons have no *style*. And so they could not write poetry; indeed, they could not write science either. I make this preliminary because I think it is very important to understand why human beings have always paid this great attention to the individuality of the artifacts that they make, to the personal way in which they express themselves.

Let us concentrate for the moment on poetry. By and large, critics have taken the line that poetry obviously has a style, and that this style depends in a crucial way on the arrangement of the words. The vocabulary, say most critics, is the words. I shall take as my example what one very attractive critic, a charming poet, A. E. Housman, said on this subject for two reasons: first, his poems are familiar to most people, and second, I heard the particular lecture from which the passage is taken, "The Name and Nature of Poetry," when I was an undergraduate. (It was an enchanting lecture, although unfortunately I think most of it is nonsense.) Now I will choose some passages in which Housman puts forward this specific point about the arrangement of the words. He quotes a passage from *The Book of Common Prayer* in English:

"But no man may deliver his brother, nor make agreement unto God for him," that is to me poetry so moving that I can hardly keep my voice steady in reading it. And that this is the effect of language I can ascertain by experiment: the same thought in the bible version, "None of them can by any means redeem his brother, nor give to God a ransom for him," I can read without emotion.

I think the passage from the Bible is pretty good, too. I would be hard put to it to decide which of those made *my* voice tremble.

However, the conclusion that Housman draws is that "poetry is not the thing said but a way of saying it." That is not a conclusion which follows from the premises — all that he has proved is that poetry is affected by the way that you say things. A little later he says of what he calls "six simple words of Milton":

"Nymphs and shepherds, dance no more" — what is it that can draw tears, as I know it can, to the eyes of more readers than one? What in the world is there to cry about?

Weeping through poetry was one of Housman's favorite exercises. Indeed, it is very characteristic that the poetry he quotes all has this curious effect, like music played in a minor key. The phrase "But no man may deliver his brother, nor make agreement unto God for him" has the sort of folksong quality of, say, "My bonnie lies over the ocean." I assure you I am not trying to make fun of Housman, I am just trying to clarify the point. He continues:

Why have [Milton's] mere words the physical effect of pathos when the sense of the passage is blithe and gay? I can only say, because they are poetry, and find their way to something in man which is obscure and latent, something older than the present organisation of his nature, like the patches of fen which still linger here and there in the drained lands of Cambridgeshire.

Now that cannot be true, because as I have just explained, whatever it is that is older in man is exactly *not* the ability to say things in two ways. "Poetry indeed," he concludes, "seems to me to be more physical than intellectual."

Here I must add a passage which is not strictly relevant, but which I remember hearing with such pleasure that I cannot refrain from quoting it. You must think of Housman, who was by this time a very old man, reading:

Experience has taught me, when I am shaving of a morning, to keep watch over my thoughts, because, if a line of poetry strays into my memory, my skin bristles so that the razor ceases to act. This particular symptom is accompanied by a shiver down the spine; there is another which consists in a constriction of the throat and a precipitation of water to the eyes.

Now this is a way of talking about the subject in which there is an element of truth. It is obviously very important that the choice

of words in a poem in some way leap like an electric spark from the poet to the hearer and give the hearer the ability to recreate the poem. Moreover, the most obvious way to think of this, as Housman suggested, is to think of the emotional or musical quality of the poem. I use the word "musical" because, you see, we think most readily of poetry as musical or impressionistic. To take an example almost at random, I used one of the paintings of the west front of Rouen Cathedral by Claude Monet in my last lecture. Monet was the first of the Impressionists, and, indeed, the word "impressionist" was coined by an adverse French critic in 1874 when Monet exhibited a painting called *Impression, Sunrise*. Now those paintings of the west front of Rouen Cathedral at different times of day, or the paintings that Monet did in London of the Thames and the bridges, or the paintings he did at the end of his life of the water lilies in his garden, are marvelous paintings, and they have exactly this sense of transmitting something which seems to have little to do with the structure of the painting, but a great deal to do with the mood, the impression, the music. Yet if, in fact, one looks closely at the paintings, that is not the final judgment we pass on them today.

And similarly, if one looks closely at a musical poem, that is not, in my view, the final judgment one makes. Let me make this comparison very fair by choosing what, to my mind, is one of the most beautiful musical poems in English, written by Thomas Campion in the Elizabethan age. And since Campion wrote largely to music, this is a poem which was no doubt written with the notion that it would be sung and no doubt written to a musical pattern:

Kinde are her answeres,
But her performance keeps no day;
Breaks time, as dancers
From their own Musicke when they stray:
All her free fauors and smooth words,
Wing my hopes in vaine.
O did euer voice so sweet but only fain?
Can true loue yeeld such delay,
Conuerting ioy to pain?

Lost is our freedome,
When we submit to women so:

Why doe wee neede them,
When in their best they worke our woe?
There is no wisedome
Can alter ends, by Fate prefixt.
O why is the good of man with euill mixt?
Neuer were days yet cal'd two,
But one night went betwixt

Now I think that is a gorgeous poem, and if ever I try to think of a
musical line offhand, I always think that the first quatrain has
something which very few poems, in English at any rate, have.
Yet as soon as one gives any attention to the poem, one is struck
by the fact that there is a great deal more than music going on. I
remember, for instance, when I read the poem first, being puz-
zled by the fact that line two says, "her performance keeps no
day." Why "day"? Because there is a joke coming at the end of the
poem, "Neuer were days yet cal'd two, But one night went be-
twixt." And that is a visual joke about day and night which has
nothing to do with the music of the verse.

And again, if we take the lines:

Lost is our freedome,
When we submit to women so:
Why doe wee neede them,
When in their best they worke our woe?

All that is not just a question of impressionism, of music in the
sense of Debussy and the tone poem. The music has a very strong
structure, and we are suddenly reminded that, of course, the cen-
tral element of music is exactly the structural element.

I referred in my last lecture to the notion that the use of words to
work magical charms played a large part in Renaissance incanta-
tion. Why did they think that you could command either other
people or nature by a particular musical arrangement of words? It
was because they thought that music expressed the central har-
mony of the world. They thought that every planet had a special
music, a special picture, that if you put those together it gave you
some kind of entry into nature. You heard the music of the
spheres. And the phrase "the music of the spheres" comes from
Pythagoras, whose other great achievement was the theorem
about the right-angled triangle — I think that they are about equal

achievements. Pythagoras thought that the world was so constructed that the lengths in it also had a musical significance. Music and mathematics went together in his mind and in the minds of the people like Marsilio Ficino who sang orphic hymns in the late fifteenth century and believed that he influenced the course of the world by that means.

The geometry of the music, the structure of the music, was supposed to reflect profound structural elements in the way the world is put together. So the word that I come out with from the discussion of music is the word "structure." Every piece of music — every classical piece of music, at any rate — has a powerful movement and march (which indeed is a march of ideas) just as much as the idea in Campion which goes from "day" in line two to "day" in the last line but one.

At this point I thought it was time to ask a prosodist to analyze a poem that I knew and to see how his reading of it compared with mine. So when I was planning this lecture I asked an old friend of mine, the great Russian linguist and prosodist Roman Jakobson, to write a piece about a specific poem and what its musical and prosodic effects are. Russian linguists are not given to brevity, so I will read you some selections from his piece which I believe to be wholly characteristic and which I hope will make my point. He writes about a very short poem of Blake's called "Infant Sorrow":

1. My mother groan'd! my father wept.
2. Into the dangerous world I leapt.
3. Helpless, naked, piping loud:
4. Like a fiend hid in a cloud.
5. Struggling in my father's hands,
6. Striving against my swadling bands.
7. Bound and weary I thought best
8. To sulk upon my mother's breast.

That is the whole poem, those four couplets, as published in the *Songs of Experience* of 1794. There were, however, five other verses in Blake's original draft which he simply crossed out; he decided that these two contained the crux of the matter. Jakobson says:

The two lines of each couplet are bound by a rime, and the odd couplets of the poem differ from the even ones in the structure of

their rimes. Both riming words of each odd couplet belong to the
same morphological category, end with the identical consonantal
inflectional suffix, and differ in their prevocalic phonemes: 1*wep-t*
– 2*leap-t*, 5*hand-s* – 6*band-s*. In contradistinction to the odd coup-
lets, the even rimes confront grammatically dissimilar words;
namely, in both cases an adjectival adjunct rimes with an inani-
mate noun. The entire phonemic make-up of the former word
appears to be included in the second member of the riming pair:
3*loud*–4*cloud*, 7*best*–8*breast*. The identical formal make-up of the
two odd rimes emphasizes the divergent semantic orientation of
the two quatrains, viz. the conceptual contrast between the inau-
gural preterits and the inanimates looming over the second part of
the poem which are, *nota bene*, its sole plurals.

Just so that you shall see what he means by this, he is saying that
lines 1–4 have a highly personal sort of internal arrangement;
whereas lines 5–8 have an obvious sort of arrangement of con-
flicts of a different character. He goes on:

The geometric style of Blake's verbal art involves a startling
dynamism in the development of the tragic theme. The coupled
antisymmetric operations outlined above and the categorial con-
trast of the two parallel grammatical rimes reveal the tension be-
tween the nativity and the ensuing worldly experience or, in lin-
guistic terms, between the initial supremacy of animate subjects
with finite verbs of action and the subsequent prevalence of con-
crete material inanimates used as indirect objects of verbal nouns,
viz. gerunds derived from verbs of action and subordinate to a
verb of cogitation. . . .
The same raising motif of weary resignation is embodied
within the rhythmical pattern of the poem. Its initial octosyllable
is the most symmetrical of all eight lines. It consists of two tet-
rasyllabic coordinate clauses with an expressive pause between
them rendered in Blake's text by means of an exclamation point.
An optional secondary pause emerges between the subject and
predicate of both juxtaposed clauses. The second of these contras-
tive pauses precedes the final syllable of the line: 1*My mother* :
groan'd! | *my father* : *wept*. In the next line, which concludes the
first odd couplet, the internal syntactic pause arises before the
second to last syllable (6 + 2), and with each line the interval be-
tween the final and the internal pause becomes one syllable
longer, until the last line of the second odd couplet fixes the inter-
nal pause after the second syllable of the line: 2 + 6. Thus, the
widest swing which the verse takes (2*Into the dangerous world* | *I
leapt*) changes gradually into the shortest span (6*Striving* | *against
my swadling bands*).

Now I think all this very subtle, very ingenious; but it leaves one with an extraordinary feeling of astonishment. One is tempted at this stage to ask, "Did Blake sit down with a computer and write the thing, saying 'Aha, you see, the odd rhymes must have two consonants, but the even rhymes must have single liquid consonants' and so on?" To this, Jakobson would of course reply rightly and indignantly, "Don't be silly. What I am saying is simply that the human brain works in this way; the poet's mind works in this way; the finding of words has this quality; and it, as a result, expresses what the poem is about." And I think that that is absolutely true. Although at first I was rather shocked when I read this long, prosodic essay, at the end I felt rather deeply respectful. Because I know what the poem is about. It is very simple. It is about the fact, which is constant in Blake's life, that he had an attitude to the world which was in part respect for the male dominant principle, and in part a great rebellion against it. And the rebellion often took the form of retreating to something that he was rather afraid of, like D. H. Lawrence — the feminine aspect of experience with which afterwards he then always quarreled. And I think that that is exactly what the poem is about. The young man (who occurs in all Blake's poems) confronts the world with a tremendous sense of conquering it, and then immediately meets head on the world as it actually is (lines 5, 6). If one reads other verses by Blake, one sees how he is constantly arguing about this, but in this verse he is willing just to make do with saying:

Bound and weary I thought best
To sulk upon my mother's breast.

For this, you see, is one of the poems of experience; this is not in the *Songs of Innocence*. One of the things which he said in the poems of 1794 was that we are constantly being defeated by the world. Blake wrote the *Songs of Innocence* in 1789 when the French Revolution was just bursting upon the world and there was a mood of exhilaration and optimism; the young man steps out in the sunlight, and he is going to conquer the world. Orc, the great figure in the French Revolution poems who stands for Blake himself, is going to conquer alone. But by 1794 England is at war with

France; Blake has been heavily defeated by all kinds of difficulties; many English intellectuals are being prosecuted; Tom Paine has fled to France; the laws against seditious writings have been published; and repression starts and now really lasts until Blake's death. Blake lived on until 1827, but the fact is that from 1784 on he never was in this kind of mood of optimism which the *Songs of Innocence* had once brought. Lines 7 and 8 of our poem represent the kind of retreat that he thought was the only way open to people once they were faced with these dilemmas.

Now Jakobson, talking about how the poet chooses the words, and I, talking about how he chooses the images, come out with something which I hope conveys the sense that the style and the content have to be a unity of this kind. You will recall that my second lecture was much concerned with the notion of putting together the visual image and the word to make a symbol, an emblem, which contains within itself the complete expression of some likeness by which the poet or the painter attempts to make you experience an inwardness in the world which there is no way of communicating to you unless he makes you reexperience it. This Blake poem makes it clear that the metaphor works at three different levels: universal metaphors; the metaphorical system of the poet; and the special range of metaphors used in a particular poem. When you think of words like "My mother's breast," "My father's hands," you are conscious that Blake is appealing to metaphors which are universal. We all understand that. We know perfectly well that when the metaphor has these peculiar human qualities, then it is one that we would recognize in any situation in any poetry of any country. Then there is a second level of metaphor which is very peculiar to that poet. In Blake this is very strong.

I want in a moment to come back to some parts of "The Tyger," which I quoted in my first lecture. In that poem and in the one I have just been considering and elsewhere there are certain themes which would lead you to say instantly, "Why, that is by Blake." In my last lecture I quoted a line from Shakespeare's *Antony and Cleopatra*: "For her owne person, it beggerd all discription." And I compared the visual quality of the image with

Blake's, "The Beggar's Rags, fluttering in Air." Now the latter line simply could not have been written by anybody but Blake. And that is because that kind of symbolism, poetic image that also has a strong social punch, is inherent in the way that he wrote poetry. Every poet has a set of images, a kind of metaphorical world which he inhabits, which is not shared by the rest of the human race. And that is the level at which he is different from the rhesus monkey and the gibbon and the bower bird. They certainly have a metaphorical world of their own; after all, what are all words but images or metaphors of some kind, even in the most primitive monkey language. But to shift from that world into a highly personal world which we feel tells us one poet's personality, that is the characteristically human move. And that is a move that you have to make *with* the poet. There is nothing in the poetic statement which can give you instructions for doing that, unless the imagery carries itself. And this is why I was so anxious to say that this compounding of the word and the visual image makes a unit which we recognize as a means of direct access to communication with us.

Now I said that there are three levels at which literature speaks. There are these universal metaphors which all human beings share and which we recognize at once (mother, father, hand, breast, mountain, sea) — all the things of which popular songs are made. And then there are the ones which are characteristic of the poet, like Shakespeare's ability to say, "Daffadils that come before the Swallow dares." But then there is a third level on which I shall concentrate in my next lecture, and that is the imagery which is peculiar to *that* poem, like the things that a painter paints in *that* picture and not in all the other pictures.

It is really only in recent years that we have become aware how much a poet changes his set, his mode of attack, when he starts a new poem. The best-documented case now is that of Shakespeare because in the last thirty or forty years Caroline Spurgeon and Wilson Knight and a number of other critics have done elaborate word counts on the images in Shakespeare's plays and have come up with the extraordinary information that a given play has a quite characteristic set of images which is different from that of other

plays. For instance, *Macbeth* is full of the words "black," "blood," "night," and all those other things which apparently, as it were, entered Shakespeare's head the moment he sat down and started writing the play. He knew from the first scene with the witches what kind of play he was going to write. And at once, out of the enormous range of his imagery, that was the set that he selected. In *Antony and Cleopatra* (from which I quoted in my last lecture) there is a very characteristic set of images which starts with the first lines of the play when two soldiers come in and one says to the other: "this dotage of our General's ore-flowes the measure." Images about excess, exaggeration, prodigalness, and the like dominate *Antony and Cleopatra*. And so we could go on from play to play and classify the major images.

Now it may seem very tedious to count the images in Shakespeare. Just as I started by thinking it was really rather tedious to take a poem by Blake and have Roman Jakobson count up the syllables and tell me that the odd rhymes were different from the even rhymes. And yet, in a way, at the end of all this you have an enormous impression of a single personality. There really is a person who is writing the whole of that play. He is not just writing the odd rhymes or the even rhymes; he is not just writing this play or that play — it is one person. And when people sometimes say, "Oh, well, what would it matter if *Love's Labour's Lost* had turned out to be written by somebody else?" the answer is, it would be devastating. One could not really conceive that *Love's Labour's Lost*, indifferent as it is in many ways, could ever have been written by anybody but the young Shakespeare. Because he is a person, this is the way he is growing up. You can see what he learned in the smart conversation that the country boy had been picking up in London when he started to write *Love's Labour's Lost*, and it is all there. And by the time you come to the great, grim tragedies of 1600, 1605, 1610, then you see that this personality has been shaped with a kind of personal magnificence in which you have seen the bones set and the muscles harden; and that is how he is going to talk in *Troilus and Cressida*.

In this sense, the style of the work of art, and of the whole output of an artist, is intimately related to its content. Style has

many components which together make up this relationship, but I propose to concentrate on the element of imagery. This is the element which joins the immediate experience that a poem presents with more remote facets of experience; it draws analogies to what is at hand from what has been experienced at another time. Many scientific discoveries also do this. Probably the ability to make such analogies is characteristic of the creative person, both in art and in science; and such persons display a special unity of mind of which the unity between the style and the content of their work is an expression. Let us look at some examples.

I have chosen some Sumerian ideograms of 3000 B.C. (figure 16) to remind you of the sort of things that human beings do which the rhesus monkey and the bower bird do not do. Notice the strongly visual element, even though this is just a piece of writing. The people who made those ideograms were on their way to the alphabet in which our poems are now written. And the way to that alphabet lay exactly in the way they looked at nature.

The gold cup by Cellini (figure 17) comes from that magical period to which I tend to refer over and over again — the Renaissance. And many of the animal symbols in it have this magical quality. But it is undoubtedly intended to represent, in visual, enormously rich terms, that universal harmony of which that age was so enamored.

I chose the medieval knight in a falcon headdress (figure 18) to remind us of the relations that we always aspire to with animals, and the kind of person that we read into the animal. What is so interesting about the knight's accoutrements is, for example, the falcon's expression; he really looks like an elderly politician. And the number of replicas of this aggressive symbol that the knight wears in order to give himself courage is, I think, gorgeous.

The plate of *Nature and Art* from Robert Fludd's *Utriusque Cosmi . . . Historia* (figure 19) comes slightly later in that particular magical age. It is a very elaborate piece of symbolism about nature and art and the signs of the zodiac, and represents the last gasp of that tradition which was trying to find a magic. It is an extremely interesting piece because at this time people were arguing about

the Copernican system. And people like Fludd were also deeply involved in this, but to them, you see, it was all entirely magical in this way. (Notice the little monkey, sitting on the globe in the center, who was a very important figure in the relations between man and nature for that period.)

Figure 20 shows Leonardo da Vinci's drawing of a mortar firing multiple shrapnel shells. It is probably a very important invention; only recently Ladislao Reti realized that Leonardo may well have intended that it be powered by steam, in which case it was probably the first steam-powered engine of that age. But the reason I chose it is that here he is making an ordinary engineering drawing of one of his mad inventions (and one of his dreadful inventions, because really for a man of his talent to have spent his time making designs for war for Ludovico Sforza, the tyrant of Milan, "it beggars all description"), and no sooner does Leonardo start drawing the engine on the right than all that flowering of his talent comes out on the left. And if you saw the left only, you would think of it as being some quite different naturalistic drawing, depicting the harmony of nature rather than of machinery.

I chose Paul Klee's *Bird Garden* (figure 21) because we often forget that Klee's naturalism has a very strong geometrical structural element. And again it seems to me a superb way of showing that for him the imagery has this strange quality, so that nothing is wholly naturalistic, and nothing is wholly man-made.

Marc Chagall's *Midsummer Night's Dream* (figure 22) contains the strong metaphorical element of which all his painting is full. This is a rather extraordinary painting because usually the animals do not have the intimate, human place that they have here. This might well be an illustration to Shakespeare's play. (It is usually called *A Midsummer Night's Dream*, but I doubt whether Chagall called it that. I think he just called it something like *Nice Man, Lovely Lady*.) But to Chagall the painting simply represents something about the relations of people and the way their animal nature, that metaphorical nature, has an essentially earthy element. This was quite as important to him as that curious angelic figure up in the top left-hand corner.

I would like to end by discussing William Blake's illustrated poem, "The Tyger" (figure 23). (You must not look closely at the tiger because Blake and his contemporaries had never seen real tigers; they had only seen stuffed animals. And this one had been very badly stuffed indeed.) I want to emphasize that the style is expressed not only by the rhythm of the words, not only by the choice of the words, but much more by the fact that a poet has a *theme*, and that his imagery always draws out of that theme and passes that theme on to us. Here it is expressed very strongly. You see, the tiger is a crucial question in Blake's mythology. He would have liked to feel that nature was sweet and kind and that we ought all to be very nice to one another, as indeed he did. And yet he also had this very strong feeling that (what T. S. Eliot calls "Christ, the tiger") the attack on the world, the quarrel with the way the world is, has to be carried out not simply by sitting down and moaning about it.

The principal theme in Blake's mythology is always the theme that taboos are wrong. Consider the lines we discussed earlier:

Struggling in my father's hands,
Striving against my swadling bands.

Now I do not know any other poem in which Blake uses the particular image of the swaddling bands. It came to him at this moment, but it is characteristic, and the swaddling bands are exactly what in a famous and great poem, "London," Blake called "the mind-forg'd manacles":

In every voice, in every ban,
The mind-forg'd manacles I hear.
How the Chimney-sweeper's cry
Every black'ning Church appalls;
And the hapless Soldier's sigh
Runs in blood down Palace walls.

And this antiauthoritarian note in Blake is what, of course, makes the tension in that poem about the mother and the swaddling bands and the father. And here it is in "The Tyger" in which he just asks exactly these questions because he would have liked to be both a lamb and a tiger. And so would we all; I mean, that is what the human dilemma is about:

In what distant deeps or skies
Burnt the fire of thine eyes?

Fire is an absolutely constant image which runs everywhere through Blake, so that you can hardly turn the page without coming upon it:

On what wings dare he aspire?
What the hand dare sieze the fire?

And what shoulder, & what art,
Could twist the sinews of thy heart?
And when thy heart began to beat,
What dread hand? & what dread feet?

What the hammer? what the chain?
In what furnace was thy brain?

Blake is the first English poet to whom the Industrial Revolution was real, so that

In what furnace was thy brain?
What the anvil? what dread grasp
Dare its deadly terrors clasp?

for the first time carries that smokey, sulfurous imagery which later on came to dominate his poems more and more.

When the stars threw down their spears,
And water'd heaven with their tears,
Did he smile his work to see?
Did he who made the Lamb make thee?

Tyger! Tyger! burning bright
In the forests of the night,
What immortal hand or eye
Dare frame thy fearful symmetry?

The theme that I have put forward in this lecture is that people lightly speak about the music of the poem, the way that it is constructed. When you really begin to look at that, it stands for a very strong structural framework in the poem. And the successful poet, the poet who really carries his message, is the one to whom the words come that have this particular power. But in the end, the words are most intimately bound up with that great fund of imagery which is a poet's real way of thinking. What he does for you, what he does for us all is always to produce a metaphor in which we suddenly see two separate parts of the world, and we say, "My God, why did I not think that they belonged together?

Why did I not think that 'What the hammer? what the chain? In what furnace was thy brain?' goes with the kind of thing that a tiger is? Why did I not think that 'When the stars threw down their spears, And water'd heaven with their tears' is the right way of saying that God is full of pity — he wants to make the Lamb, but in the end the instrument has to be the tiger?" And it is the essence of poetry, as of painting, as of all art, to communicate that, to leap over the gulf between us — to make the metaphor suddenly speak to us, not so that we understand it, but so that we recreate it. Style is the means by which we recreate the content for ourselves.

16
Tablet with Sumerian ideograms. Babylonian Collection, Yale University.

17
Gold cup, attributed to Jacopo Bilivert. Gold, enamel, and pearls; sixteenth century, Italian. Known as the Rospigliosi Cup. The Metropolitan Museum of Art, Bequest of Benjamin Altman, 1913.

Integræ Naturæ speculum. Artisque imago.

18
Knight in a falcon headdress. *Manesse Codex*, Universitäts-bibliothek, Heidelberg.

19
Nature and Art. From Robert Fludd, *Utriusque cosmi, maioris scilicet et minoris, metaphysica, physica atque technica historia* (Oppenheim, 1617, 1619), I, p. 3. By permission of the Houghton Library, Harvard University. Photograph by Barry Donahue.

20
A mortar firing multiple shrapnel shells. Drawing by Leonardo da Vinci. *Codex Atlanticus*, 9 v-a, Ambrosiana, Milan.

21
Bird Garden (1924), Paul Klee.
Watercolor. Munich, private
collection.

22
Midsummer Night's Dream
(1939), Marc Chagall. Musée
de Peinture et de Sculpture,
Grenoble.

23
"The Tyger," from *Songs of Ex-
perience* (London, 1794) by
William Blake.

4
THE ACT OF RECOGNITION

In this lecture I want to analyze the crucial difference between the way in which an ordinary statement or representation speaks and the way in which a work of art speaks to us. As usual, I shall concentrate on poems, but what I have to say is, I believe, applicable quite generally to musical, visual, and literary works.

Toward the end of his life Aldous Huxley wrote a book called *Literature and Science* in which he attempted to analyze the difference. It is an attractive book, full of nice quotations both from literature and from science. But it is the book of a man writing at the end of his life, and saying more often things that he remembers than things that he has thought out afresh. The crucial difference that he proposes to mark the statement in ordinary speech or in science from a literary statement is this: the literary statement, the poem, is always highly particular, whereas the scientific statement is always highly general. Now, in some sense what Huxley says is very true, nor was he the first person to point this out.

Let us take an example: I quoted in my first lecture one of the great formulas in science, powerful in its place in history, pertinent even today — Newton's formula about attraction. Newton says that two massive bodies attract one another in proportion to the product of their masses and inversely in proportion to the square of the distance between them. That is the inverse square law which, when Newton published it in the *Principia* in 1687, marked a turning point in the whole conception of what a scientific formula should say. Now, it is certainly true that this is a highly general statement. It applies to all bodies; it does not discuss their color, their history, what they mean to you, why they frighten or interest you. And in the same way it sets up a relation with distance which has no ambiguity at all — at least, no ambiguity other than a possible one about measuring distance, which did not arise for another 200-odd years.

Now, if we compare this to some short, succinct statement by a poet, we see at once how much more particular the poet's statement is. I have quoted before a couplet of Blake's: "The Beggar's Rags, fluttering in Air, Does to Rags the Heavens tear." Let

me take the poem from which that comes, "Auguries of Inno-
cence," which consists of a long list of such couplets, including
the following:

A Robin Red breast in a Cage
Puts all Heaven in a Rage.
A dove house fill'd with doves & Pigeons
Shudders Hell thro' all its regions.
A dog starv'd at his Master's Gate,
Predicts the ruin of the State.

Now phrases of this kind are obviously highly specific. They
work for you because you have feelings about the dog, about the
Master, about the Robin Red breast. It would be true to say what
Housman said in the passage I quoted in my last lecture — that
here poetry is not the thing said, but a way of saying it. And the
way has to be, as Huxley says, highly particular — specific. Or so
it seems in the case of Blake. We know that this is so, because if we
take the first two lines, the content presumably is that to cage a
living creature is a fundamental outrage of nature. That is some-
thing Blake said over and again all his life, and in "The Marriage
of Heaven and Hell" he has a phrase for it which consists of only
four words, "Damn braces: Bless relaxes," which says the same
thing as "A Robin Red breast in a Cage Puts all Heaven in a Rage,"
though not nearly so well. It does not, as it were, go straight as an
arrow to the heart and the head and make us feel that there is
something wrong with nature, there is something wrong with our
treatment of nature, if we put birds into captivity. Just as in one of
the other couplets we feel there is something wrong with the soci-
ety in which the dog at his master's gate is starved. We have the
sense of criticism of both human and social action, which the par-
ticularization of the verse carries in a way that no general state-
ment does — not even those wild general statements that Blake
was fond of making like "Damn braces: Bless relaxes." You could
say, in a sense, that "Damn braces: Bless relaxes" is exactly like
Newton's formula about the product of the masses and the in-
verse square of the distance. And in some way "A Robin Red
breast in a Cage Puts all Heaven in a Rage" is much more power-
ful than that.

So far, we see, with all that tradition which Huxley repeated in his book, that the particular statement of the poem *is* more powerful. But just when we reach this stage, we also see that there is something fundamentally wrong with this, because "A Robin Red breast in a Cage Puts all Heaven in a Rage" is *not* a statement about robin redbreasts. As a matter of fact, if it were a statement about robin redbreasts it would be incomprehensible to an American reader, because Blake never saw any robin redbreasts except the English ones, which are not the same species as the American robin redbreasts. So if it were a scientific, highly specific statement about the robin, it is highly unlikely that it would be true in the two countries. But, an American reader *does* understand what Blake said, even though the species of bird is not the same for such a reader as it was for Blake.

And this is the point at which we should ask ourselves, "What does carry the message? Indeed, what is the message?" Very well, that is not a statement about robins, and "A dog starv'd at his Master's Gate" is not a statement about dogs, and "The Beggar's Rags, fluttering in Air" is not a statement about beggars. Then what are they about? They are statements about what kind of behavior in Blake's mind corresponds to the way of nature; robin redbreasts ought to fly free, masters ought to have a kind of human regard for their dogs, a society ought not to tolerate beggars who go about in rags. What the verse says is in fact a highly general statement, quite as general in any sense as Newton's statement about the attraction between two masses. It describes something which we feel to be a social criticism. It describes it in terms which for some reason speak very immediately to us, but it is not true that the message of the poem is any more particular than the message of the kind of interchange that you have with the grocer, or that Newton has when he puts down an equation in the *Principia*. The fact is that powerful human statements (statements which have a wide meaning for many people), whether they are in prose or verse, whether they are in painting or music, or whether they are in the form of political exhortation or of scientific statement, all such statements have a wide degree of generality. So whatever the message of the poem is, it is certainly a very general message.

The question we then have to ask ourselves is the following. We understand that the scientific statement about masses and distances is general in what it describes, and uses general categories, namely "mass" and "distance." We understand that the poetic statement is general in what it describes — about being encaged, about being starved, about being poor — and yet there the statement is carried by a highly particular example. We all realize that just saying "bird" for "Robin Red breast" would not have the same punch. We all realize that saying "four-footed mammal" for "dog" would not have the same punch. And we all realize that "The Beggar's Rags" has a force which no substitution of some Marxian statement about "people who are devoid of the ownership of the means of production" could conceivably carry. So the real question we have to ask about the work of art is, How in the world does it speak so powerfully to us in using the particular to carry a general message?

I am going to say that this occurs because of a special way in which the human mind works. Namely, we not only speak in language but also think in language, and the poet in some way by using the particular enters not only our public communication but our private thought. But the best way to do this is by taking a straightforward poem with a very simple message and analyzing it. The poem I have chosen is by Dylan Thomas.

The force that through the green fuse drives the flower
Drives my green age; that blasts the roots of trees
Is my destroyer.
And I am dumb to tell the crooked rose
My youth is bent by the same wintry fever.

The force that drives the water through the rocks
Drives my red blood; that dries the mouthing streams
Turns mine to wax.
And I am dumb to mouth unto my veins
How at the mountain spring the same mouth sucks.

The hand that whirls the water in the pool
Stirs the quicksand; that ropes the blowing wind
Hauls my shroud sail.
And I am dumb to tell the hanging man
How of my clay is made the hangman's lime.

The lips of time leech to the fountain head;
Love drips and gathers, but the fallen blood

Shall calm her sores.
And I am dumb to tell a weather's wind
How time has ticked a heaven round the stars.
And I am dumb to tell the lover's tomb
How at my sheet goes the same crooked worm.

As in so many of Dylan Thomas's beautiful poems the central thought here is very simple, and consists in verse of the confrontation of the same two ideas. One is the idea of the green fuse driving the flower, of the power in nature quickening the trees at this moment, bursting the flower through the branch, coming out like a sort of rocket through the fuse of the branch. Against that there is an opposing idea which is that in this progression also we are destroyed. At this moment the power of spring is quickening the trees. We feel the bursting of life in those; and yet we also know that it reaches into the roots, it will destroy the tree. The very act by which the tree or nature is burgeoning now, is also one by which time is destroying it: "The force that through the green fuse drives the flower Drives my green age." The contrast of "green" and "age," this contrast of two opposing words, occurs repeatedly in the poem. Now if we were to read the first verse alone, we could find in other poems a great many analogues of what seems its simple sentiment. Take the following translation from Rainer Maria Rilke's *Duino Elegies*, the beginning of the Sixth Elegy:

Fig tree, for long you have held full meaning for me,
the way you almost entirely omit to flower
and into the seasonably resolute fruit
without fanfare thrust your purest secret.
Like the tube of a fountain, your bent bough drives the sap
downwards and up: and it leaps from its sleep, scarce waking,
into the joy of its sweetest achievement. Look:
like Jupiter into the swan.

The image of the fountain, the image of the drive of youth and sex, the image of Jupiter and Leda:

und er springt aus dem Schlaf,
fast nicht erwachend, ins Glück seiner süssesten Leistung.
Sieh: wie der Gott in den Schwan.

Now this is superb poetry, but by the time you have got to line four, you absolutely know that you are with Rilke and you know

exactly where he is going to go. He is going to lead up to sweet achievement, Leda and the swan and a well-formulated statement of the theme of achievement which is characteristic of the poet. Moreover, the imagery here is essentially Rilke's imagery; you could be sure that he would be swept away by the pictorial quality of the fig tree, the way the branches go over, the way the fuse of the branch has this shape, the swan's neck.

Now that is exactly what Dylan Thomas is not saying. He is not making a kind of preordained simple statement of this kind. (Not that I wish to denigrate the work of Rilke, which is superb. I have, after all, read only a few lines from one of ten-odd elegies.) But what Thomas is packing into this poem is a much more searching and appealing opposition. The question is, Why is he doing it in this way? Why is he not satisfied like Rilke to take an image of the flower, to carry it through the swan image, human achievement, the act of sex, the whole feeling of youth thrusting upward? The answer is that in him the image is deeply related to a dichotomy, a tearing asunder of the human personality. As the first stage we have "the force that through the green fuse drives the flower," and the opposition to that is "that blasts the roots of trees Is my destroyer." In verse 2 we have

The force that drives the water through the rocks
Drives my red blood; that dries the mouthing streams
Turns mine to wax.

The image is of the surge of water and then the water drying up in the desert of the long hot summer.

The hand that whirls the water in the pool
Stirs the quicksand; that ropes the blowing wind
Hauls my shroud sail.
The lips of time leech to the fountain head;

This is the same image of the fountain which we have just had in Rilke, but for Dylan Thomas it holds a different message:

The lips of time leech to the fountain head;
Love drips and gathers, but the fallen blood
Shall calm her sores.

And this seems to me a particularly interesting verse; it encapsulates the opposition Thomas is expressing.

Now if this were a formal statement, then of course we would simply say that it is very repetitive; no scientist would write out the same proposition in five different and particular versions of this kind. And the answer to that must be that the repetition has some kind of power which is intended to set *you* on fire. You may be a person like me who takes fire at the word "fuse" in line 1; you may be a person, on the other hand, who takes fire at the word "love" in the last passage I quoted; or you may have a quite different cast of mind, and the word "hangman" may be the one that strikes straight at your heart. But in some way this enormous elaboration of metaphors finds a word, an image, a simile which is yours, and in terms of which the poem somehow enters into your mind and unfolds into it.

We may think of the scientific statement as sailing, as it were, straight through the ear on a kind of majestic course and coming out as a precise statement, speaking in the same generality to me that it held for the speaker. Here we have quite a different picture. One of those metaphors (Dylan Thomas's, or Blake's dog or robin redbreast or beggar) somehow enters us, and from that moment we shape the poem, we recreate the poem, because there is a moment in which it speaks our inner language. There is a distinction between the outer public language that we all use and the inner language which we as human beings work with in our heads all the time, the language of our own imagination. And it is to that language that these poetic statements appeal.

What, after all, does the poem *say*? It says when you are young growing older is wonderful, but when you are old growing older is tragic. Write that in any number of psychology books and it will not carry the particular meaning that the imagery does here. When you are young growing older is a coming of experience, an unfolding of new things, things that you have not witnessed or been part of before, and each day that passes is "driving through the green fuse" and going into the future which is opening for you. And that is in Rilke's poem, but it is only part of the story. The other part, which comes in Dylan Thomas's poem as the antistrophe in every verse, is that when you are old growing older is

tragic, because whatever the new experience is, you have the frightful sense that it is not really worth the rate at which death is approaching.

I took a poem by Rilke to illustrate the first part of this thesis. Let me read you a very beautiful poem by W. B. Yeats to illustrate the second part about growing older. This is a poem called "Why Should Not Old Men Be Mad?"

Why should not old men be mad?
Some have known a likely lad
That had a sound fly-fisher's wrist
Turn to a drunken journalist;
A girl that knew all Dante once
Live to bear children to a dunce;
A Helen of social welfare dream,
Climb on a wagonette to scream.
Some think it a matter of course that chance
Should starve good men and bad advance,
That if their neighbours figured plain,
As though upon a lighted screen,
No single story would they find
Of an unbroken happy mind,
A finish worthy of the start.
Young men know nothing of this sort,
Observant old men know it well;
And when they know what old books tell,
And that no better can be had,
Know why an old man should be mad.

Now this is a very old man's poem. What it lacks by comparison with Dylan Thomas's poem is the sense not only that this is how life is, but that it somehow is the price you have to pay for being alive. You have to pay the price that the future looks open and that there comes a strange moment — you never know at what moment in the tunnel of your life it happens — when suddenly instead of the tunnel opening out in front of you it seems to be closing in. And that is what Dylan Thomas's poem is about. When you are young growing older is wonderful, and when you are old growing older is dreadful.

My reason for laying such stress on the Thomas poem is not that I think he was a better philosopher than either Rilke or Yeats — as a matter of fact I am sure he was not. I am sure that as staid

gentlemen of well-rounded opinions they both had a more uni-
fied view of life. Dylan Thomas did not have a single-minded
view of life. He would not have died in such sad circumstances if
he had been more single-minded. But in this poem he holds the
whole spectrum of human experience exactly because he did not
have a well-formed philosophy. He was able somehow to catch
parts of our personality which we all recognize. So that in some
sense his poem speaks to the young and to the old, to the person
to whom the word "hangman" echoes or to the person to whom
the word "love" echoes. He makes us recognize ourselves in
some part of the situation of the poem, and in that way he makes
us recognize ourselves in the whole human situation.

I want to be very clear about this. I have not chosen this poem
for analysis because I think it to be more profound than others,
but because it happens to contain in itself enough diversity,
enough of the power, uncertainty, and restlessness of a young
poet, to be a sort of kaleidoscope of all the parts that make up the
human character. And in the end, through the work of art, we
penetrate into the human character because one facet of that
kaleidoscope is a door to us. We are able to enter the human situa-
tion through that because that is part of our experience. And sud-
denly we see that the work of the artist reveals to us the fact that
we catch ourselves in his creation; and then we realize that the
whole of creation, all human thought, is also contained in us. That
we are no more alien to the hangman, the sadist, the lover, the old
man, than we are to ourselves. Every human personality is
unique; but it is unique because it contains within itself a special
arrangement of all those things that we all share. And what the
work of art does is to catch some single opening, some facet of the
kaleidoscope, which acts as a door through which we suddenly
see that, by Jove, by Leda, this is us, and the old man is not differ-
ent from what we are going to be, and the young man is not dif-
ferent from what we were, and the murderer is not following any
impulse that we do not share. We understand not just this person
and that person but the whole human predicament. Because
something in the poem has dragged us in through that doorway
and suddenly shown us the whole human personality.

It is this that I regard as the central activity of the work of art, and it is in this sense that the particular metaphor seems to me to disclose something of the universality of the human situation — not because you can say it in the particular metaphor, but because the particular metaphor is what drags it through your mind, into your mind, and so into a picture of all humanity. Let me now turn to a few illustrations which will I hope give the same sense in pictures.

I have chosen the detail from the *Peasant Wedding* of Pieter Bruegel the Elder (figure 24) because it is a straightforward painting, with no elaborate imagery required. And yet you have only to look round that to realize that what I have said about imagery is also true about the depiction of persons in it. All the little things that are going on in the picture, such as the boy handing out the plates, say something about the peasant wedding. They describe the nature of the wedding and the nature of human beings in a way which speaks to you directly.

Figure 25 is a more fantastic Bruegel. It is a detail from the Great Masquerade, *The Fight between Carnival and Lent*, in which again I have the sense that the four hundred years that have passed since it was painted in no way change its character even though here the people wear masks. They are disguised, and yet their various actions and the symbolism of the cards and the bones and the broken egg shells all have this same ability to bring to life in us not a set of characters whom we watch like actors, but a set of different projections of parts of our own personality.

Toulouse-Lautrec's *Rue des Moulins* (figure 26) shows what I suppose was a fairly ordinary scene in a brothel in Paris just less than a hundred years ago. The girls are so charming — just look at the smile on the face of the redhead. This makes us aware of the fact that even acts which we prefer to carry on in private give a certain amount of pleasure, and even the exhibition gives a certain amount of satisfaction which we understand. The smile on that girl's face is not something outrageous, it is something with which we very well understand our own sympathy.

Figure 27 shows one of the drawings done by Henry Moore in the London Tube in 1940 or 1941 when people were sheltering from the air raids. There are a great number of these, and they all have this same sense of people being assembled in a state of semianimation. The people who went down into the shelters held onto their lives, but while they were in the shelter they seemed to exist in a state of suspended animation, as if they had been frozen for a time. I was very struck by this myself the first time I went into an underground shelter in London at that time. Moore's drawings are thus very immediate to me because there are no expressions on the faces. There are no faces, there is nothing even very special about the posture. The mother with the child on the left, the other people sitting by, are all people who are somehow neither alive nor waiting for the day of judgment; they are simply there waiting for life to begin again in the morning.

I spoke in earlier lectures about symbols and emblems and often gave the impression that they had a highly artificial air, and therefore I thought it right to show a crucifixion. The one in figure 28 is by Duccio. It conveys the sense of Christ not being simply an emblem on the cross but really being crucified, which speaks for all human suffering. That is the essence of what the Christian sacrifice is about. We should remember it. And we should remember that you can make no symbol like the cross without there standing behind it a figure in an agony which you have not experienced, but whose quality you understand.

I do not claim to be able to explain to you what all the detail means in the painting by Max Ernst called *Oedipus Rex* (figure 29). But the painting represents the action by which King Oedipus puts out his eyes when he finds he has committed incest. And the sense of that animal nature on the right, of the darts and surgical instruments that will put out the eyes, has the particular power which makes the Oedipus Rex legend speak today exactly as it did at the time that it was conceived.

I chose René Magritte's *Time Transfixed* (figure 30) because it gives me enormous pleasure: it is both funny and true. I think it has all the best of surrealism in it. Look at the chimney space which contains no fire, but you see there is an engine in which the

fire is burning and the smoke is going up the chimney. Yet somehow this curious engine and the clock are supposed to tell us something about time rather than about mechanical power; and I imagine that what they say is that the force that makes coal give warmth or produces power in the engine is of the same character as that which I described in Dylan Thomas's poem. Why do those particular metaphorical images seem so vivid to me? In part, of course, because they are comic (and that I think is an important element in art). But in part because what Magritte and other surrealists were trying to do was to remind us that we live in an age in which the greater part of our environment is man-made, in which the natural environment no longer has the directness for us that it used to have. And the images of the man-made environment — the railway engine, the clock, the mirror, the candleholders, and the rest of the room — ought to convey to us the same sense which Dylan Thomas draws only out of natural imagery. If I have one criticism to make of the poems that I read by Rilke, by Thomas, by Yeats, it is that in a curious way they are suspended in a timeless world as if only trees and rivers were the human environment. And what the surrealists, and Magritte in particular, said is that there really is the same message in the man-made environment.

The various details in Pablo Picasso's *Guernica* (figure 31) seem to me to say very exactly how we all share through imagery a part of the totality of the human experience. None of us has really seen a horse in a room in which a bomb has fallen. None of us has seen the bare electric light. None of us has seen that curious ox creature on the left which comes out of some Greek legend, or those broken figures. And yet that concentration of the agony of human revolt, of indignation, in this picture enters our minds in a way that no description of the scene and no political appeal based on the scene could do.

Let me then summarize for you the theme of this lecture. Through previous lectures I have laid great stress on the fact that the total vocabulary of the artist — poet, painter — consists of something in which the style and the imagery are one. It is through this that he communicates. That total vocabulary in the poems that I have

chosen reaches you through metaphors within the poem, reaches you through statements about the flower and the root, the river and the sand, the youth and the shroud, reaches you in oppositions like "green age" or "wintry fever." Why are those images able to make so profound an impact? It is not because art consists of highly particular statements and science consists of highly general ones. It is because art communicates extremely general statements in such a way that the person who made them speaks, and you who hear them recreate them for yourself.

We become one with the whole of creation because we receive a statement which is not finished, which does not say "mm'/r^2 is proportional to the force between two massive bodies." On the contrary, the work of art is essentially an unfinished statement. It presents you with this so that you will make your own generalization from it. And of what does this generalization consist? It consists of a statement which is not the same as the artist's and yet which could only come from him to you because in the wealth of imagery that he employs there is something which speaks to your inner language, so that you reform the poem or the picture for yourself.

Now the question is, Why should you do that? And the reason is that human beings, unlike any other animals, have this extraordinary double personality. We know ourselves as individuals but we also know that what goes on inside ourselves is also almost exactly what goes on inside everybody else. Almost, but not quite. We are all individual. We all have our own inner language. We all speak a public language in which we try to communicate what we have in common. But in the end, we seize what we have in common with the human race as a whole, because we make ourselves one with the artist. We suddenly say, "I see why he does that, I see why this horse has such power, I see why Picasso keeps on painting these bulls." And, we also say to ourselves, "Ah, that's the Oedipus, a universal symbol." This bull is a symbol which you find in all Picasso, a symbol which runs through all his work. But that single electric light up in the ceiling belongs to this picture alone; that is something which struck him with powerful force for this picture. He is saying something about

the mechanical world, and he is not saying it by drawing an enormous number of bombs but just by drawing one electric light bulb. And in some way that one electric light bulb speaks more directly to us about a mechanical society which can produce this kind of horror than any number of descriptions in terms of megatons of bombs. I called this lecture "The Act of Recognition" because when we catch the sense of the image and its echo in us, we recognize ourselves in the artist, we recognize ourselves as one with his creations, and conversely, we recognize the whole of the human race within ourselves.

24
Detail from *Peasant Wedding*,
Pieter Bruegel the Elder.
Kunsthistorischen Museum,
Vienna.

25
Detail from *The Fight between
Carnival and Lent*, Pieter
Bruegel the Elder. Kunsthis-
torischen Museum, Vienna.

26
Rue des Moulins (1894), Henri
de Toulouse-Lautrec. Chester
Dale Collection, National Gal-
lery of Art, Washington, D.C.

27
A Tilbury Shelter Scene, Henry
Moore. The Tate Gallery, Lon-
don.

28
Crucifixion (center panel of a
triptych), Duccio di Buonin-
segna (Sienese School, 1255–
1319). Purchased, Grant
Walker and Charles Potter
Kling Funds, 45.880. Courtesy
Museum of Fine Arts, Boston.

29
Oedipus Rex (1921), Max Ernst. Private collection. Paris.

30
Time Transfixed (1939), René Magritte. Courtesy of The Art Institute of Chicago.

31
Guernica (1937, May–early
June), Pablo Picasso. Oil on
canvas, 11' 5.5" × 25' 5.75". On
extended loan to The Museum
of Modern Art, New York,
from the artist's estate.

5
IMAGINATION AS PLAN
AND AS EXPERIMENT

When I began these lectures, I drew attention to my choice of title, *Art as a Mode of Knowledge*, because, I said, it is unusual to think of art either as expressing or communicating knowledge. Through the lectures since then, I have built up the sequence of artifact, word and image, and finally the notion that in the work of art the image has the special quality of trying to direct from the artist to you an immediacy which other generalizations lack. It was specifically the point of my last lecture that it is *not* true that the statements implied in works of art are any less general than those implied, say, in science. And yet it is clear that the work of art has a quite unique capacity, which is this: that by some profound and obscure mode it directs you into the general statement and somehow makes it resound in you as if it were your private property.

I chose to contrast a characteristic scientific generalization, namely that the gravitating force between two massive bodies falls off as the square of the distance, with a couplet from Blake:

A Robin Red breast in a Cage
Puts all Heaven in a Rage.

The question is, How does the specific image of the robin and the cage somehow communicate to you the sense that life ought not to be lived under duress? Which is a highly general statement, at least as general as anything Isaac Newton said, and yet which reaches you with an immediacy which no prose statement of an ordinary kind (certainly no scientific statement) does. No, the work of art is not trying to say specific and very particular things to you. Nothing in that couplet by Blake really has anything to do with robin redbreasts. That is an illusion, and yet it is exactly that illusion which has the power to open your mind and enter into it, and carry with it the force of all the other examples that that generalization implies.

I have called this lecture "Imagination as Plan and as Experiment." The contrast that I shall develop has to do with exactly this point: How do we imaginatively enter the experience of other people, including both the experience about which the artist writes or paints (the content), and the experience that the work of art expresses (the style)? Why is it that human beings feel themselves involved in these statements and have done so since long

before Newton was born and long before that way of expressing generalizations had a wide audience? Take the robin redbreast and the cage. Of course, Blake is not talking about robin redbreasts, he is talking about human beings, both what they do to nature — the deformation, the dislocation of nature — and also what they do to human beings, "the mind-forg'd manacles." How is it that we as individual people are capable of experiencing this in ourselves and yet recognize it as something that other people feel as well? This is the crucial nub of the work of art: its ability to communicate to us something which we instantly recognize as an echo of our own experience and in which we see unfold a sense of universal human experience.

There is a famous passage in one of John Donne's later sermons which says "No man is an Island, entire of itself." As it goes on, the passage says only that we are dependent on other people, that you should feel a sympathy with them. But it carries the heart of the message that I am concerned with here. "No man is an Island" because the island that he is, is part of the total archipelago of human nature. And as you see yourself in that, you suddenly realize that everybody is rather like you although you are essentially individual. It is the echo in yourself of everything about human beings which makes the work of art expressive and indeed enormously exciting to you. And I call it a mode of knowledge because it is my view that for much of our life we do in fact only learn about what life is really like because we catch these echoes, these other facets of the enormous kaleidoscope of the human character into which the artist's individual image carries us.

Now let me pause for a moment and compare what I have been saying with a nice down-to-earth scientific statement. (It happens to be a statement from the social sciences, which I do not regard as having quite the same validity as the science that I practice. But let us accept it as a scientific statement.) Some years ago a Dr. D. McClelland made a study of the fairy stories and children's books of twenty-two nations. And he classified the books into two groups: those which instilled in children a wish to achieve something in life, and those which instilled a sense that the goal of life

really was to obtain power over other people. (I am not going to comment on this distinction, I merely repeat what Dr. McClelland found.) He found that he could divide the twenty-two nations on the strength of his classification of children's books that had been published in them in the year 1925; and by the year 1950 it was true that the nations did fall into two different groups. (He chose to measure the difference, you may be surprised to hear, by the increase in electricity production and the national income.) He concluded that what was being said in the children's books did indeed reflect something about what is usually called "the national character." What he was measuring, of course, was essentially how people in a nation are taught to look up to the great heroes in their society.

Now more recently Dr. S. A. Rubin carried out a study in which he took McClelland's classification and said roughly this: "If this distinction is true, then those nations which set a high regard on achievement should have a high rate of peptic ulcers and heart attacks. And those nations which set as their aim the sense that the individual should have power ought to have a high rate of murder, suicide, and the like." So he did a classification of children's books against the rate of peptic ulcers and the rate of suicide. And that yields a fair correlation also.

I will not hide a certain note of mischief at quoting these social statistics. But what I am trying to say to you is that when you look at statistics like that, you are looking at the overall shape of ambition in a country: either the ambition for personal achievement, or the ambition for power to dominate other people. The point is that if you want to look for these characteristics in *literature,* you will have to go to folk tales, to fairy stories, to children's books; it is no use going to the real works of art and the real works of literature, because they start exactly where the statistics leave off, exactly where three times the standard deviation peters out. *That* is where the work of art is created.

What the work of art says is, Yes there is a statistical "national character," but the individuals in each nation are very complex people. Each one of them is a complete person. And however much he may drift in the general way of life with the others, what

he really reads for, what he really goes to an art gallery for, is some expression of his personality which is not contained in the statistics — indeed, which is not contained in *any* statistic. In the end what the work of art says to him is, "You cannot choose between achievement and power. You cannot choose between being young and being old. You cannot choose between being a marvelous woman with thousands of lovers and feeling a quiet sense of duty to your husband and children." Because everybody wants to be all those things at the same time. Everybody wants to be all aspects of humanity. And they realize these different facets, they see the total human picture in the work of literature, in the imagination which shows them that the small facet of their character which goes this way or that is also a facet of the total human character. Dylan Thomas's poem made one of these simple contrasts and I will remind you of it:

The force that through the green fuse drives the flower
Drives my green age; that blasts the roots of trees
Is my destroyer.
And I am dumb to tell the crooked rose
My youth is bent by the same wintry fever.

You will recall that I called this an exciting poem because it says that when you are young it is marvelous to be growing older and when you are old it is terribly sad to be growing older. And that is what life is about. And that in the end is what literature is about and what painting is about, in the sense that it constantly tries to say to us that human beings are not machines, do not have a "single ruling passion" (as Pope said). And all their problems are essentially insoluble.

There is a passage from Gertrude Stein's *The Mother of Us All* which says that rather elegantly:

We cannot retrace our steps, going forward may be the same as going backward. We cannot retrace our steps, retrace our steps. All my long life, all my life, we do not retrace our steps, all my long life, but.
(A silence a long silence)
But — we do not retrace our steps, all my long life, and here, here we are here, in marble and gold, did I say gold, yes I said gold, in marble and gold and where —
(A silence)

Where is where. In my long life of effort and strife, dear life, life is strife, in my long life, it will not come and go, I tell you so, it will stay it will pay but
(A long silence)
But I do want what we have got, has it not gone, what made it live, has it not gone because now it is had, in my long life in my long life
(Silence)
Life is strife, I was a martyr all my life not to what I won but to what was done.
(Silence)
Do you know because I tell you so, or do you know, do you know.
(Silence)
My long life, my long life.

This is a superb statement of what I have been saying, in much more poetic terms. But in addition it tells you something important about the work of art, namely, that the stranger the style seems to you, the more you should ask yourself, Why does that writer write like that? And after you have read all those stylistically unfamiliar things by Gertrude Stein (like "A Rose is a Rose, is a Rose"), a passage like the one I quoted suddenly makes you realize that the problems that preoccupied her could only be expressed for her in that way. All that haunting, repetitive manner was to say that there is no forward way in life as she saw it, but that there is only this complex of insoluble but marvelous problems.

There is a remark by C. P. Snow in *The Two Cultures* about how tragic it is that we are all alone: "Each of us is solitary: each of us dies alone." Well, that is what the work of art is supposed to break down, but you see in a way that is not really true, that is not the problem of life. We are part of an archipelago of human nature of which each of us is a different island, a different facet, but the real crux of life which one learns as one grows older is that there are no soluble problems. And that is the great lesson with which you have to be satisfied. That it is not *solving* the problem which is what life is about, but *living* the problem. And that when you read the work of an artist, what he tells you is not how things are, how things are done, how a human being acts; he tells you how a human being *is*.

It is when you realize that this is the communication between yourself and human beings — or rather, between yourself and

human nature — that the artist sets up, that you realize why we are all fascinated and attracted by the kind of book which is an experience of outrageous dimensions. When Dickens was an old man, he used to go about reading from his books in public, and his readings always made a great sensation because he liked to read the criminal passages from his books. These passages had a prostrating effect on him. He read the great passage from *Oliver Twist* in which Bill Sikes murders Nancy and then in trying to escape over the roof catches himself on the noose and hangs himself. This passage had a devastating effect on Dickens; whenever he read it he had to rest for several hours afterwards. He was very ill by this time; he had some kind of illness in one foot (probably psychosomatic) and could not walk very well. His doctors pleaded with him not to read this passage, but just this he had to read. He had to read it because of something to do with his childhood and the prostrating effect which living for a short time in slums and with thieves had on him. But above all he had to read it because obviously he felt that those parts of his nature which showed a kinship with murderers and criminals wanted to come out. He wanted for a moment to be Bill Sikes committing murder and dying.

And all of us want at times to be something like that. That is why most censorship is so pointless, because it is in recognizing ourselves in just such actions that we suddenly see that people in whom that is really a dominating power are not so much to be blamed as enormously to be pitied. At the end of *Oliver Twist*, we pity not only the child, not only Fagin, not only the Artful Dodger, but we even pity Bill Sikes. Because suddenly we realize that there but for the grace of God goes any one of us. And we mean by that not that this or that social difficulty created such a person; no, we simply mean that in all of us there are all facets of human nature, and we never know in advance which one of us will take command. It is pointless to say about another human being, "Oh he is bad through and through"; that is not what it is about. This is the human situation. This is why the problems are insoluble.

In my first lecture I quoted lines from one of my own poems. I would like at this point to quote the closing speeches from a play of mine called *The Face of Violence*, in which I was thinking about just these questions:

Castara:
The man made a journey,
Begun in passion
And driven by purpose;
And now the journey is done.
The resolute man whom a purpose sustained
Now has none.

Pollux:
No. The man made a voyage,
And the end of the voyage was discovery.
He went out to explore
The jungle within the heart
And the continent under the dark mind.
What else was there to find?
What is there to show at the end of a voyage of exploration
But a scar and a scribbled chart?

Castara:
And shall these modest mementos suffice
From a search that encircled
The orbit of the lurching earth
And the three-ringed circus of Saturn?
Will the man be content,
After the navigation of tempests,
To ride home on his bicycle
Down the hill into the little yard below the grocer's?

Pollux:
He went of course by way of adventure.
Like every explorer, he wanted it to be
All freaks and supermen:
Water-rats as big as torpedoes,
And a dwarf with the Jack of Diamonds
Pinned in the place of his heart.
He set off in a big way.

Castara:
He went by way
Of all the rituals of violence:
The boxing booth, the slum, the Roman circus,
The saturnalia and the matador,
Frankenstein and the tales of Poe
And Dickens screaming in the part of Bill Sikes.
He went by way of the films

And the headlined gangster;
But he left them, to speak to a man in the crowd at Tyburn.
Pollux:
How purposeless then, he learnt, had been his long obsession
With the spy and the watchful cripple and the message in code.
Had someone betrayed him? It was the man down the road.
The witness in black
Was a char he'd had to sack.

This dialogue restates this sense that we only go wrong when we try in our lives to live the extravagance directly. Yet it is that which moves us most deeply in literature and in art because we recognize a part of ourselves which will never be expressed at other times. And this is the sense of kinship with humanity as a whole which art communicates.

I said that we get from the work of art not only what it is like to *act* as another man does, but what it is like to *be* as another man is. I think that this is crucial because the outcome of actions is a perfectly proper scientific study. That can all be done with formulas and statistics and people classifying twenty-two sets of fairy tales into unequal piles. It is not the point of the work of art that at the end it shall tell you, Do this or do that. What the work of art does is to tell you how things will fall out, but also what it feels like to be that man. Go back to Bill Sikes: dramatically it is, of course, tremendous that he hangs himself by accident; but that is only a dramatic trick, the real thing that the book tells you about all the people in it is what it is like to be such a person, whether you could stand it, the conflicts that arise.

So we see that there is indeed a mode of knowledge which the work of art communicates. It is not the knowledge of the mechanics of life or even of the outcome of living in a certain way. Rather it is knowledge of what it is like to be this kind of man and every kind of man. In the end what the book and the painting is about is to present to you those unresolvable conflicts, to present them to you essentially as conflicts of conscience.

The word "conscience" is a suitable one at this stage, because conscience means to feel, to know with — it is knowledge with another person. An old word for conscience in English is "inwit." It is a word which has not been used for some hundreds of years,

but it says just that, what it is like inside. It is a form of knowledge which you gain not by a statistical comparison with how many murderers succeed, how many escape unhanged. Conscience is a form of knowledge which you get because you become aware of what it is like to be that particular person. At the end of *Anna Karenina* you do not feel that she was bound to commit suicide — because she was not. Every dramatic ending is in the end a kind of device, whether it is in *Othello* or in *Hamlet* or in *Macbeth*. No, the point of the book is in the book. What *Anna Karenina* conveys to you is the agony of a woman who is torn between that particular tearing passion of love and her perfectly clear knowledge that the man she is in love with is wholly unworthy of the devotion that she is giving him. Now that is not exactly anybody else's problem, and yet it is exactly the match of every human problem.

Drama shows this so much better than other forms of literature that I would like to give you an example. What is *Othello* about? It is about the fact that if a black man marries a white girl it usually ends badly. You know we did not need Shakespeare to tell us that. Then you ask, "Is it about black men and white girls at all?" The answer is, Hardly at all. Just as Shylock in the *Merchant of Venice* is a person whose Jewishness has really very little to do with the character, so the fact that Othello is in fact a distinguished black general in the service of Venice has very little to do with anything else except to sharpen the image, to make the contrast tighter. So what is the play about? The point of the play is that a man, particularly a man who has other reasons to think that his wife may not have the devotion to him that he hopes, is given to jealousy. What kind of jealousy? Someone steals a handkerchief from her and look at all the fuss he makes about it.

If the moral of *Anna Karenina* is, when depressed do not go near railway stations, then the moral of *Othello* is, hold on to your handkerchiefs. And when you say it like that it sounds incredibly trivial. But that is the point about jealousy; it always fastens on what are highly symbolic situations: gifts which have no value at all. If Othello had come raging in and said, "You have lost my diamond ring, and I paid $20,000 for it," everybody would have

said, "Well that is fine. He did not need to murder her for it, but anybody can see why he is cross." But she did not lose a diamond ring, she did not lose anything which was worth anything at all. She lost a highly symbolic gauge. It was stolen from her and the man who stole it, that mephistophelian character, is in fact a kind of god or devil in this, who knows that it is with trivial symbols that you enter and operate on the human mind.

In a sense *Othello* is exactly a play which says what literature is about. It is about the fact that a spotted handkerchief suddenly makes us all feel, "That is what tokens of love are." Everyone has had something given to them which at any moment they can re-capture, and they can smile to themselves with understanding. I have a tie which I wore the first time I met my wife. It is now over thirty years old. It is highly unfashionable, I shall never wear it again. But every year when it comes to throwing out my ties, I say in a sheepish sort of way, "Perhaps it will become fashionable again." And that is what *Othello* is about; and all the enormous elaboration which is built on that takes off from this tiny symbolic pin.

Now, having talked about how we enter and identify ourselves with the human situation in others, and particularly in outlandish conduct, I want to make two concluding points. First of all, it should now be clear why I talk about "Imagination as Plan and as Experiment." Imagination as plan is important. Science, statistics in general, solving problems, is an important imaginative activity; but it is not the imaginative activity of the arts, because that is constantly experimenting with situations like that. You can be quite sure that when Shakespeare started the play he did not really know how it was going to finish. I do not mean that he did not know that he was going to have Desdemona strangled in bed. But he did not know what the last speeches were to be, and he never thought that suddenly he would be saying in the second scene of the play, "Keepe up your bright swords, for the dew will rust them," and all those other things which leapt out of his head as he wrote. I know this because I know that it happened to me

when I wrote *The Face of Violence*. It seemed so clear what I was going to say, but what in fact I said was in some mysterious way determined by the characters.

Now this sense that every work of art is an experiment in living is what I want to convey to you, coupled with the fact that reading the work of art is your experiment in living it. And I mean that. I am repeating what I have said before, that the work of art does not exist for you unless you also recreate it. Nobody's reading of *Othello* is the same as mine. Nobody is moved by the same parts. You will recall that when I read you the Dylan Thomas poem I pointed out how there were words in each verse which would appeal as images to other people, and how the contrast of sand and water in one might mean more to you than the contrast of bough and root of the tree in the first verse.

You recreate the work of art when you see it, when you hear it, when you read it, because you enter into it, and the little words, the little images, suddenly take off in you and it is you who remember about the tie or the token or something else which gives a direct path into your experience and suddenly makes you feel that yes, that is what life is about. Not my life, not his life, but just being a human being. It is for that reason that I began with the statistics about the fairy tales and the folk tales and the twenty-two nations. Because those are not experimental, but the work of art is. And it is experimental in what it says, in the situations it portrays, but also, therefore, in the way that it is done. From my first lecture about the artifacts I have kept returning to this point, and I have made it here as well as I know how to make it by quoting the passage from Gertrude Stein. Because here is a woman of whose writing most of the time you say to yourself, "My goodness, why does she write like that? The style gets in the way." But when you get a passage in which she is really saying what she has to say, you suddenly realize that the style is exactly the only way to say it. And therefore the style is as experimental as the message.

The twenty-two nations and their children's books really belong to a world of dogma, a world of trying to make everybody alike. But ever since the Renaissance, the Western world has op-

erated on the belief that human beings are highly individual and that the exciting thing about being a human being is matching your individuality with how other people are. That is what the experimental style displays. The most striking way in which it displays it is actually in self-portraits. In 1300 nobody painted self-portraits; yet the self-portrait has been a very important kind of work of art since the Renaissance because of the artist's sense that he wants to look inside himself and outside at the same time.

My second concluding point is this. The work of art is not the solution of any specific problem like deciding, say, which way to go home from work — whether Pennsylvania Avenue at that time of the day will have more traffic, or whether it is better to go to Massachusetts Avenue. We do not form a plan to reach a particular and well-defined objective, as we do in a scientific problem. Rather we face the unbounded course of our life, stretching ahead of us to unclear and unbounded goals, and we learn to devise an overall set of principles which seems to us to give direction and shape to our own development. In this way we form for ourselves an ethic, a set of principles by which we characterize our own way of dealing with the situations that will confront us (and whose piecemeal solution would buffet us from pillar to post).

You have to have a sense of the direction of your own experiments: this is the way I want my life to be, this is my kind of conscience. And that ethic we get not from the specific work of art, but from the totality of our living. And we say to ourselves, "It is no use, I really could not go through all that. If I had been Anna Karenina, I would have had to give up before, I could not have stood the strain." Or whatever other kind of strategy you devise for yourself. But in a curious way, without ever articulating it, you get from these works the sense that the sort of person you are tackles his or her small problems in this large shape which we call an ethic, a set of values. And that is why my last lecture will be called "The Play of Values in the Work of Art."

Let us look now at some examples of this. Turner's *Approach to Venice* (figure 32) is a very revolutionary picture. Turner had started by painting quite naturalistic landscapes, and then his

style became what essentially led into the Impressionist movement. It is very exciting to see an artist who was already very accomplished saying something powerful as he was experimenting. This picture does not seem to be about life, and yet it is. It expresses the personality of the artist — this is how he wanted you to look at the picture, and he succeeded. When Turner painted this, nobody wanted to look at the world like that. And yet today no artist could possibly sell a picture of the kind that Turner painted before this as a young man.

Rousseau's *The Equatorial Jungle* (figure 33) has some animals in the painting which are just as funny as the tiger by Blake. And I chose this one because we all have a great sort of fondness for Rousseau as an artist, and yet it is a fondness which has a childish quality about it because we feel, What a nice, funny man. And that is also something that we say about life.

There is a great picture by Cézanne called *Le Château Noir* (figure 34). As you know, of all the Impressionists Cézanne probably transformed our vision most by an enormous obstinacy. He had a way of saying, "This is how I see it, take it or leave it." And this picture seems to me one of the extreme examples; it is about as personal a statement as you will ever get from him.

Now I have chosen a couple of self-portraits. First, there is one of a long series of self-portraits that Rembrandt painted (figure 35). (Rembrandt painted himself very often. I think he liked doing it, and also, in the later part of his life, he could not sell his pictures because nobody wanted him to paint portraits. So he thought he might just as well paint himself.) Rembrandt had a very remarkable personality. He painted this just at that stage of his life when the young, debonair cavalier has passed and the rather heavy, confident old man is to come. It is a portrait of a questioning, burgeoning, powerful man in middle life. And now look at Van Gogh's *Self-Portrait* (figure 36). The painting captures the expression of a restless, highly experimental character.

Look at figures 37, 38, and 39 together. You see a girl beginning her life, a woman in middle life, and a woman who, whatever she may think she says to her neighbors, is in fact very well aware of the fact that life has gone by. With those three portraits I want to

juxtapose an extract from a poem by François Villon; I shall quote
here from an English "imitation" of the poem by Robert Lowell
("The Old Lady's Lament for Her Youth") which beautifully cap-
tures the spirit of the French original:

I think I heard the belle
We called the Armoress
lamenting her lost youth;
this was her whore's language:
"Oh treacherous, fierce old age,
you've gnawed me with your tooth,
yet if I end this mess
and die, I go to hell.

"You've stolen the great power
my beauty had on squire,
clerk, monk and general;
once there was no man born
who wouldn't give up all
(whatever his desire)
to have me for an hour —
this body beggars scorn!

.
"Where's my large Norman brow,
arched lashes, yellow hair,
the wide-eyed looks I used
to trap the cleverest men?
Where is my clear, soft skin,
neither too brown or fair,
my pointed ears, my bruised
red lips? I want to know.

"Where's the long neck I bent
swanlike, when asking pardon?
My small breast, and the lips
of my vagina that sat
inside a little garden
and overlooked my hips,
plump, firm and so well set
for love's great tournament?

"Now wrinkled cheeks, and thin
wild lashes; nets of red
string fill the eyes that used
to look and laugh men dead.
How nature has abused
me. Wrinkles plow across
the brow, the lips are skin,
my ears hang down like moss.

"This is how beauty dies:
humped shoulders, barrenness
of mind; I've lost my hips,
vagina, and my lips.
My breasts? They're a retreat!
short breath — how I repeat
my silly list! My thighs
are blotched like sausages.
"This is how we discuss
ourselves, and nurse desire
here as we gab about
the past, boneless as wool
dolls by a greenwood fire —
soon lit, and soon put out.
Once I was beautiful. . .
That's how it goes with us."

Now in a sense I am only echoing the poem by Yeats from my last
lecture about how old men have a right to be mad because that is
how life goes; so the old woman has a right to be mad because she
really was very beautiful once. But of course, it really says some-
thing much more, and it was only a poet like Villon — a man who
really lived the extraordinary, rich life of the Middle Ages — who
could say that in the end the passage from youth to old age is not
just a process of aging but an unfolding of the ways of life. You
choose what you want out of your life, the particular set of values
by which you are going to live; and if you live by the set of values
which concentrate in what Robert Lowell so charmingly calls "the
lips of the vagina," you are rather liable to finish up like Villon's
old lady. I say that not as a piece of moralizing but simply because
that is what in the end a great portrait makes one aware of: that
every set of actions is also a way of life, a set of values. And that
the work of art exhibits the play of those values.

32
Approach to Venice, Joseph Mal-
lord William Turner. Andrew
W. Mellon Collection, Na-
tional Gallery of Art, Wash-
ington, D.C.

33
The Equatorial Jungle, Henri
Rousseau. Chester Dale Col-
lection, National Gallery of
Art, Washington, D.C.

34
Le Château Noir, Paul Cézanne.
Gift of Eugene and Agnes E.
Meyer, National Gallery of
Art, Washington, D.C.

36
Self-Portrait, Vincent van Gogh. Chester Dale Collection, National Gallery of Art, Washington, D.C.

35
Self-Portrait, Rembrandt van Rijn. Widener Collection, National Gallery of Art, Washington, D.C.

38
Lady Arabella Ward. George
Romney. Widener Collection,
National Gallery of Art, Wash-
ington, D.C.

37
A Princess of Saxony. Lucas
Cranach the Elder. Ralph and
Mary Booth Collection, Na-
tional Gallery of Art, Wash-
ington, D.C.

39
Madame Amedée (Woman with Cigarette), Amedeo Modigliani. Chester Dale Collection, National Gallery of Art, Washington, D.C.

6
THE PLAY OF VALUES IN
THE WORK OF ART

The work of art is not a slice of life. No school of realism produces replicas of some visible part of reality and simply says, "This is what reality looks like." No portrait painter who has anything important to say says only that. And if you think back to the self-portraits of Rembrandt and of Van Gogh, it will come to your mind at once that they say something else about the sitter and about the painter, particularly when they happen to be the same person, than merely, "This is what he looks like." And in the same sense no novel, no poem is simply a slice of life. It is true that the school of French novelists of whom Zola was perhaps the most important really did believe that they were presenting a slice of life. But it was interesting to recall when I spoke about the Impressionists that Zola's account of the life of an Impressionist painter (namely, his old friend Cézanne) was in fact a highly sectarian piece of work, certainly not regarded as realistic by Cézanne and Monet, and led to a breach between the painters and the writer.

Thus no work of art is simply a presentation of reality as such. At the other extreme, no work of art is simply an abstract pattern, either of paint or of music or of words. I dealt in an early lecture with the proposal that, after all, the words in a poem are so important that the poem can be regarded as a kind of musical composition. And I showed by comparing Roman Jakobson's analysis of the pattern of the poem with my own analysis of its meaning that as soon as you talk about the musical pattern — the rhymes, the vocabulary — in any depth, at once you are talking about a structure of meaning.

We stand between these extremes. Every so often people say, "The best work of art is simply realistic"; and then every so often people say, "The best work of art is simply abstract." But in fact the great works of art have been produced in periods when neither of these extremes has been held. The point of view that I have developed as these lectures have progressed is that the work of art is in some sense an experiment in living that we share with the artist. And that has two aspects to it.

First of all, we share with the artist. You will recall that I have been insistent throughout that the work does not exist on the can-

vas, in the book, until you breathe life into it. The artist creates the work, but the spectator recreates it. And you know that in the most obvious sense, every time you look more closely at the work and in a more informed way, it suddenly comes to life for you with more animation and greater depth. And even in the poems over which we have taken some pains in these lectures (Dylan Thomas's "The force that through the green fuse drives the flower," Blake's "The Tyger"), we have, I hope, all become aware that a more informed reading not only tells you more about the poem, not only makes it, as it were, more rounded in setting it in its environment, in its period, but actually makes it live in a deeper way. That is one side of the act of recreation — simply getting more out of what the poem or the portrait says by knowing more about it.

But the other side, of course, is much more important, and goes much deeper. And that is that unless you are willing in some sense to share the experience of the artist, you really never get the deep pleasure that the poem can give. T. S. Eliot said of a line from Dante, "la sua volontà è nostra pace" ["His will is our peace"], that no person who did not share Dante's religious convictions could really comprehend its ultimate meaning. I would dispute that. I do not think that you actually have to believe what Dante believed, because in a sense that is impossible. But you do have to see that it is not just something that Dante said. It is something that his whole heart and intellect entered into: for him it was a tremendously important line, and we shall not understand it if we really read it as another one of those statements like Blake's "Damn braces: Bless relaxes." Of course, it is a great problem about works of art which utter such statements as "His will is our peace" that they lack the kind of imagery that sets us on fire. I shall return to this point about imagery, which has been central to some of my lectures, but here let me go on to talk about the experiment in living.

If Dante had written only that line, or lines like it, we would regard him as probably an extremely able propagandist, but we would not regard him as a great poet. At least I do not know any great poet whose output consists only of general statements of

that kind, however deeply felt and however religiously inspired. What makes the *Inferno* come to life is the fact that you meet an enormous convolution of people whose past experiences and whose presence in hell are not merely described but are lived. When you have walked through the circles of the *Inferno* with Dante, you have met the whole spectrum of human sin, Dante's view of what is the appropriate punishment but also the sinner's own exposition of how it all happened. It is in that sense that the work of art is what I call an experiment in living. It is not merely a descriptive experiment in living, it is not merely a glorified telephone directory in which you get the addresses and telephone numbers of a series of distinguished people with thumbnail accounts of their lives. But it is an experiment into which you enter because the painter's or the poet's imagery entrains you so that you are suddenly aware that the person whose picture this is, or whose experience this is, is in some way the same person as you. You can think of yourself as having been born a twin to that person, because there is something about him which you understand and share. And until you do that you really do not understand the work of art.

So long as you can say, "That's not a very real person, those are not the sentiments that I would associate with him, this is not how it feels." So long as you can say that, you are not recreating the work of art as it should be. Now that may be on one of two grounds: because the work of art in fact is not able to do this, or because, after all, inferior works of art are like that all the time. When you really get the great work of art, when you really get into *Macbeth* and ask how Macbeth behaved, then you have to be able to say to yourself, "Yes, I understand this." It is simply no use saying at the scene in which Lady Macbeth returns with the daggers Macbeth had been too frightened to bring back after the murder, "Oh come on, she would not have done that. I do not understand that." It is no use saying about Macbeth's own feelings that in some way these are monstrous, inhuman, because only in so far as they *are* human and make you feel that such a person *could* in part have been you does the work of art really flower in you.

I spoke about the fact that you must be able to see the person talked about as a possible twin, and this reminds me that about a hundred years ago there were Siamese twins who went the rounds, and who really lived a very complicated sort of life. It is not quite clear whether they actually shared the same blood circulation, but they were very closely intertwined. And for a long time they seemed very much alike, but in middle age, toward the end of their lives, one of them really did rather take to drink and smoke too much and the other one very much resented this. And there were constant quarrels between them about the fact that there were just these differences of character. Now here they were, identical twins who had lived every moment of their lives together, they were both married, they went through all those intimacies together, and yet there was just sufficient divergence. They had a very difficult life, and I cannot for a moment blame the one who took to drink. But in some way we have to think of ourselves as being bound to an important character in a work of art, like the Siamese twins.

When you look at the Van Gogh, you really have to say to yourself, "Well, you know, cutting off your ear is going a bit far, but I do understand how that could happen to a human being." This is what I call the work of art as an experiment in living. The things that go on in it, particularly in a novel, have this force, and *Anna Karenina*, to which I referred in my last lecture, has just this. And I said then that it is no use thinking that the moral of *Anna Karenina* is that if you are feeling unhappy, do not spend your time in railway stations. There is something that the work says to you, but it never carries this simple message that if you act in a certain way, the result will be such and such. It only carries a message about how it feels not merely to act like that character, but to *be* that character.

If a work of art does not do that, then it becomes either mere propaganda or obviously comic. W. S. Gilbert, of Gilbert and Sullivan, wrote a poem called "Emily, John, James, and I" which begins:

Emily Jane was a nursery maid,
James was a bold Life Guard,

And John was a constable, poorly paid
(And I am a doggerel bard).

It goes on in this way, and I will not continue it at any length because we have more interesting poems to look at. But the point is that very soon the poem presents Jane with a straightforward choice:

But sooner or later you're certain to find
Your sentiments can't lie hid —
Jane thought it was time that she made up her mind
(And I think it was time she did).
Said Jane, with a smirk, and a blush on her face,
"I'll promise to wed the boy
Who takes me tomorrow to Epsom Race!"
(Which *I* would have done, with joy).

Well, I will not spoil the plot (the little plot that there is) by telling you what happens at Epsom. But there you have the characteristic attitude of what is essentially only a comic kind of poetry. To say that you will go to Epsom and there it will be decided which of two men you are going to marry, is a falsification of life; it suggests that the most important things in life are decisions. Now that is all very well for company directors, but for most people the most important things in life are obviously the experiences out of which decisions in the end have to grow. The decisions themselves are almost incidental in the lives of most of us, and everyone knows that if they had taken a different decision at some point, if they had married somebody else, if they had not gone to take a job here or there, life would have been different, but it would not have been as radically different as, say, the fortunes of a company that fails to sell out at the right moment.

I would contrast with "Emily, John, James, and I" a poem by W. B. Yeats called "The Three Bushes." It is a splendid poem, a troubador legend, about a woman who is in love with a man and is consumed with this love, and yet since she is a stately married woman, she is also certain that she cannot sleep with him. Faced with all these troubles, what does she do? She says to the lover, "We can only go to bed in the dark"; and then she gets her maid to substitute for her on these carnal occasions:

"Have no lit candles in your room,"
That lovely lady said,
"That I at midnight by the clock
May creep into your bed,
For if I saw myself creep in
I think I should drop dead."
O my dear, O my dear.

"I love a man in secret,
Dear chambermaid," said she.
"I know that I must drop down dead
If he stop loving me,
Yet what could I but drop down dead
If I lost my chastity?"
O my dear, O my dear.

"So you must lie beside him
And let him think me there,
And maybe we are all the same
Where no candles are,
And maybe we are all the same
That strip the body bare."
O my dear, O my dear.

After a year of this subterfuge the lover has an accident on the way
to the tryst, the woman dies of heartbreak, the maid lasts for a
long time and then confesses it all to a priest. The priest has her
buried with them; three bushes grow over the graves, which now
are so closely intertwined that you cannot tell which is which.
Now that is a story that is worth talking about, that is no nonsense
about going off to Derby Day and deciding between a policeman
and a lifeguard, that is a real story about the crux of life. And
though none of us has practiced quite this kind of subterfuge, we
all understand what is involved, and we all understand the sym-
bolic sense in which that poem says something very deep about
the life of people and something very deep about the fact that you
cannot separate the mind from the body. No literature is ever
made by a Cartesian separation at the waist.

Having said this, the next question obviously is, How do you
direct your life? If the poem does not tell you how to decide be-
tween two lovers, what good is it? I once read a number of poems
in a public lecture, one of which was a very simple sort of ballad.
My daughter, at that time aged eleven, who had been wanting to
come to one of these lectures, said to me "Which one should I

come to," and I said, "Come to the one where I read the poems."
After the lecture, I asked her, "How did you like it?" "Oh," she
said, "I thought it was marvelous. The only trouble is that the
only poem I liked was the one that you said was no good." Well
you see that was right; it is right for an eleven-year-old girl not yet
at the age of puberty and with no experience of life to suppose that
a simple story about how you should behave with a man and a
maid in very primitive circumstances is what poetry is about. She
would, of course, have loved the Gilbert poem far more than the
Yeats at the age of eleven. Now that she has reached adulthood, I
know equally well that all that has already passed, that she now
has a sense of the experience of life which makes her understand
that life does not consist of these sorts of simple solutions.

When we say that the work of art is an experiment in living, we
mean exactly that it presents to us the pros and cons, what it feels
like to be the murderer or the victim as a result of which you feel
somehow that you have entered into the lives of other people.
What is it that you get, other than merely sharing the sense of
people's lives? You get what I have called in the title of this lecture
"The Play of Values." You see, neither science nor literature con-
sists of just solving problems. In science there are many cases
where the solution to a problem does get you a step further, just
as there are points in one's life where decisions have to be made.
But in the last analysis, neither the progress of science nor the
content of the imaginative work of literature simply faces you with
a problem-solution and takes you out on Derby Day and says,
"Now make up your mind."

It has become fashionable, particularly among computer
people, to talk about problem solving as if this were the content of
science. This is not the place to worry about how scientists should
defend themselves from this impoverished attitude to their own
imaginative work, but it is certainly the place to say that it is a very
impoverished way of looking at one's own life. Think of yourself
over the next ten years. What do you want to do? What do you
want to be? Well, you have some ideas of where you would like to
be ten years from now. And perhaps there are a few people who
actually have an idea that ten years from now they would like to

be married to so and so, live in such and such a place, have so
many people look after them, and so on. But such problem
solvers are very few. What most of us say is, "I would like by that
time not to be spending my time at a job that I don't like; I would
like to have more time." And then when you ask, "What would
you like to have more time for?" the answer is, "I do not know
exactly what for, but I would like to enter into more intellectual
pursuits; there are things that I would like to have done before I
die." That is how one looks into the future, not by regarding it as a
closed, bounded plan which is supposed to reach a precise objec-
tive, the solution of a problem; but as an open, unbounded, un-
folding plan in which one sees one's life ahead and one says to
oneself, "I would like to lead this kind of life." And then you ask,
"Well, that is fine. What are you going to do about it?" The an-
swer to this is not, "I am going to take the following steps in order
to get such and such a promotion." The answer always is, "What I
am going to do about it is to guide myself by certain general, ethi-
cal rules of conduct."

You say to yourself, for instance, "I would like to live by that
time in a small community of friends. I would like to feel that the
half-dozen best friends that I have made are the ones who will still
be my friends and will be very important to me." Well as soon as
you say that you form a kind of ethic of friendship which gives to
the notion of friendship a high value and which therefore makes
you think that the way you should behave to people is one that is
likely to lead to friendship. And the way in particular that you
should behave to your friends has a special quality. And again
you cannot say of any given instance, "Should I do this or that?"
"Should I call up and ask about this?" "Should I commiserate
with, you know, the third divorce?" You always say to yourself
almost in an impulsive way, "Poor Virginia, she must be feeling
very low, I must call her." I think that life consists exactly of say-
ing, "Poor Virginia, she must be feeling very low, I must call her."
It is those three statements, it is a sense of, Here is a person, I
understand what is going on, she must be feeling very low, and I
must spill over her the kind of sympathy which comes out of the
fact that I understand this. The moment you find yourself saying

"Poor Virginia, she deserves everything that she has got: fancy marrying that man," you know that with such a person no permanent friendship can be made. It may be the same person, but if you think this — if you think that there is a radical mistake whose commission has changed her character — then you can have no sympathy. She could not be that Siamese twin that we are talking about.

I think that all ethical values have this character. The sense that we see in other people facets of our own personality and to some of them we attach value: love, loyalty, intimacy, comradeship, efficiency, skill, penetrating thought, an ability to say things well, an ability to make you laugh. And there is more of an ethic in saying about somebody, "I think he is a gorgeous person, he makes me laugh," than (if you will forgive my saying so) exists in several of the Commandments. In that sense, then, what I call "ethical values" are a strategy of life, but I want you to understand that the word "strategy" is not intended to have the sense of elaborate planning and problem solving — what I mean is a general conduct of life. The crucial thing about such values is that, in the last analysis, by none of them can you rule your life.

That is recognized even in church doctrine, where it is firmly said that there are some deadly sins and there are some nondeadly sins. What does that mean? It means that the deadly sins are those sins which you should not commit even under threat of being killed. But the other sins fall into a category in which under the dire threat of death you are allowed to commit them. Simple as that distinction is, it makes it clear that there is always a pull of values. If you are a deeply religious person, then you will not place so high a value on your life that you will commit a deadly sin. But even if you are a deeply religious person, you may place a sufficiently high value on your life to value it above some nondeadly sins.

Life does not consist entirely of sins; but it does consist of exactly this pull and push of values. Every work of art exhibits a conflict of values which is then resolved in some way; but the resolution is only one possible resolution, and you yourself may not share it. Think of all the self-searchings of Hamlet, and think

of how they have finally to be pushed aside by the suicide of
Ophelia, the death of Polonius, the final holocaust on the stage,
all of which are really attempts to get to an end in a play which is
so full of irresolutions that if you did not kill off the characters,
you could not possibly persuade anybody that the resolution
made any sense at all. This question of the conflict of values I
would like to put to you in a poem by the contemporary Greek
poet C. P. Cavafy about Darius and his court poet (the translation
is by Rae Dalven):

The poet Phernazis is composing
the important part of his epic poem.
How Darius, the son of Hystaspes,
assumed the kingdom of the Persians.
(Our glorious king Mithridates, hailed as
Dionysus and Eupator, is descended from him.)
But here we have need of philosophy; we must analyze
the sentiments that Darius must have felt:
perhaps arrogance and drunkenness; but no — rather
like understanding of the vanity of grandeurs.
The poet reflects profoundly on the matter.

But he is interrupted by his servant who enters
running, and announces the gravest news.
The war with the Romans has begun.
The bulk of our army has crossed the frontiers.

The poet is dumbfounded. What a catastrophe!
How can our glorious king Mithridates,
hailed as Dionysus and Eupator,
possibly occupy himself now with Greek poems?
In the midst of a war — just imagine, Greek poems.

Phernazis is impatient. How unfortunate!
At a time when he was positive that with his "Darius"
he would distinguish himself, and shut forever
the mouths of his critics, the envious ones.
What a delay, what a delay to his plans.

But if it were only a delay, it would still be all right.
But let us see if we have any security at all
in Amisus. It is not a very well-fortified city.
The Romans are the most horrible enemies.
Can we get the best of them, we
Cappadocians? Is that ever possible?
Can we measure ourselves in a time like this against legions?
Mighty Gods, protectors of Asia, help us. —

Yet amid all his agitation and the trouble,
the poetic idea persistently comes and goes. —
The most probable, surely, is arrogance and drunkenness;
Darius must have felt arrogance and drunkenness.

Well that is a delicious poem exactly because the poor motives
of the poet himself are exhibited in his analysis of what he regards
as the poor motives of Darius, about whom he was going to write
a poem of praise, although he was haunted by the feeling that the
only reasons why Darius had reached those heights were arro-
gance and drunkenness.

The balance of values in the work of art is something which I
have exhibited to you in a number of poems, particularly, you will
recall, in the poem by Dylan Thomas in which we constantly came
on the fact that when one is young it is wonderful to grow older,
but when one is old it is very sad to grow older. There is a poem by
E. E. Cummings in which you get just the same contrast to which
I pointed in the poem by Dylan Thomas: the tendency to put side
by side two words of opposing meanings to get this effect. This is
Cummings writing about his father:

my father moved through dooms of love
through sames of am through haves of give,
singing each morning out of each night
my father moved through depths of height

this motionless forgetful where
turned at his glance to shining here;
that if(so timid air is firm)
under his eyes would stir and squirm

newly as from unburied which
floats the first who, his april touch
drove sleeping selves to swarm their fates
woke dreamers to their ghostly roots

and should some why completely weep
my father's fingers brought her sleep:
vainly no smallest voice might cry
for he could feel the mountains grow.

Lifting the valleys of the sea
my father moved through griefs of joy;
praising a forehead called the moon
singing desire into begin

joy was his song and joy so pure
a heart of star by him could steer

and pure so now and now so yes
the wrists of twilight would rejoice
keen as midsummer's keen beyond
conceiving mind of sun will stand,
so strictly(over utmost him
so hugely)stood my father's dream

The force of this poem to me is that Cummings recognizes that
when he was a child his father stood for all those opposing things,
the depths and the heights, the sea and the uplifting, the stars and
the sun and the joy and the misery. And what seemed so marvel-
ous about his father is that somehow his father would make it all
right, everything would be resolved by that touch, by that dream.
But, of course, we are back to my eleven-year-old daughter. The
point of every life is that what your parent once did for you, you
have to do. You have to grow up and you have to become a person
in whom these oppositions are worked out so that they do not tear
you to pieces. And in an age in which so many people suffer
nervous breakdowns and spend much of their time in a helpless,
unhappy isolation, that is really an important thing to say. That
you will never make your life work if you think it is going to work
in a simple plan. If you really think that saying, "I am going to be
loyal to this, and it is going to serve me through life," will work —
it just does not.

Einstein was a pacifist all his life. In 1939 Szilard and Fermi
persuaded him to write a letter to Roosevelt saying, "It looks as if
the Germans are making an atomic bomb, and that being so, we
really cannot neglect this threat." Well now, it took a great deal to
make Einstein sign that letter, but he — a lifelong pacifist —
signed it. And at the end of the war when, against his wishes and
Szilard's, the bomb had been used, he said, "If I had known that
the Germans had not got any way at all, I would not have lifted a
finger." Of course, if you always know what the others are doing,
life is very simple. But at a given moment you have to make some
kind of decision, and very often you have to live the rest of your
life with the fact that your decision may have been wrong. And it
is useless going about eating out your heart over a wrong deci-
sion. Like Einstein you must shrug your shoulders and say, "That
is how it went." And if you do not do that, if you allow yourself to
be eaten by many of the miseries which, say, Oppenheimer felt

over decisions that he had made, you really become a very unhappy man (as the Oppenheimer investigation makes very clear).

Heinar Kipphardt's play, *In the Matter of J. Robert Oppenheimer,* is extremely revealing in just this sense, because it is perfectly plain that Oppenheimer is a delightful person who shares all our doubts in every direction. And yet at the same time, you see, he wants to make history. History is made by bigots. People of wide and generous views make science and poetry and many imaginative arts. But you just have to make up your mind. If you want to make history, you must be like Stalin and Hitler. But if you want to be something more, if you want to be a loved and wise and delightful person, who is in a sense only the expression of history, then you really must be a person, and you must have all these feelings. It is not a matter of heroics. It is really a matter of a profound sense of reflecting in yourself those aspects of humanity. Oppenheimer did that, but he also wanted to be on the President's Advisory Council; Einstein did not want that.

The work of art which does not set out to explore what I have called "the balance of values" but which pretends there is *one* point of view, a unique solution, is mere propaganda. And the difference between this and the genuine work of art will show up clearly if we look at some illustrations.

Tiepolo's *Queen Zenobia Addressing Her Soldiers* (figure 40) shows you the simplistic view of history. It says, "That is what greatness looks like," which is just what I have been attacking. This is a picture which is propaganda, and you do not feel any sense of being the twin of any person in this picture. I regard it, brilliantly as it is executed, as a kind of cardboard picture, and I think that in a sense you can see this in the painting as much as in the sentiments.

In case you think that only imperialist pictures make me feel that they are rather one-sided, I have intentionally chosen a revolutionary picture by Delacroix, *Liberty Leading the People* (figure 41). It has this same quality, athough it is more exciting. And the bare bosoms of the girl waving the red flag are supposed to tell you that this is the way to live. But the fact is that this is not it either. No single one-sided statement of this kind really gives you any idea of what living is about.

And in order to leave you in no doubt about that, I have chosen the print *Napoleon Crowned with Laurels* (figure 42). The moment it gets as decisive as that, the effect is at once comic. And, of course, this painting is the poem about Epsom Day translated into a piece of Napoleonism. It is funny because the drawing is so bad. But, of course, the artist felt that good sentiments made up for bad drawing.

I chose Salvador Dali's *The Sacrament of the Last Supper* (figure 43) with a certain amount of hesitation, because I do not really think that Salvador Dali is as bad as people make him out. On the contrary, I think that he had many moments and painted very fine pictures. But this picture seems to me to be a projection into religious sentiments of the same kind of monochrome attitude that we have seen in the other pictures. And therefore I place it next to a sketch of *The Last Supper* by Leonardo da Vinci (figure 44). Now *that* is something else. It is an early sketch, and it is an extremely interesting one, because you will notice the figure of Judas sitting on our side of the table. At the time Leonardo drew this, that was the way you drew Judas — that was the way you drew the Last Supper. Judas always had to sit what we in England call "below the salt" — on this side of the table — because he was in disgrace. But when Leonardo actually painted *The Last Supper* in Milan, Judas was sitting round the table with everyone else. He had suddenly felt that this simplistic interpretation of religion was not right, and that set up a great tradition.

I chose *The Massacre of the Innocents* by Pieter Bruegel the Elder (figure 45) because it is supposed to be a scene at the time of the birth of Christ. And yet you see that it had for Bruegel the intensity of a massacre happening in a village that he knew in his own time. Look at the general picture for a moment, and then look at the man begging for his life in the foreground, and look at the man with a dog, and the people running away, and children being brought to be massacred by the soldiers. So far as Bruegel was concerned, this was, although a biblical scene, exactly like drawing children being dragged away to be killed or to be taken to a concentration camp.

In figure 46 there is a momentary detail from the Bruegel paint-
ing of a woman with her child being pursued by two soldiers and
a dog. Now that is not about something that was happening in the
Bible, that was something Bruegel felt about power and arrogance
and humanity and slaughter in his own day.

The last two pictures I chose will take you into a quite different
world, the world of late nineteenth-century intimacy and plea-
sure and particularly of the relations between men and women.
Look at Renoir's *Les Parapluies* (figure 47). To me that is a picture
which you can only appreciate if you understand everything in it,
for this is the spectrum of life. You must understand the little girl
with the hoop in the background, and the mother looking on, and
you must understand the man making a pass at the modiste in the
foreground, and you must not feel about any one of these people
that they are just horrible dirty old men.

And, finally, figure 48 shows one of the famous Saltimbanques
pictures by Picasso. It belongs to a particular period in Picasso's
life and is one of a set of pictures that had a tremendous influence
on Rilke. Rilke started the *Duino Elegies* in 1911 or 1912 and then
broke off, and he tried again and it took him ten years to complete
them. One day in 1922 he wrote to several people and he sent a
telegram to one saying, "I have finished, the ten elegies are all
written." And that afternoon he wrote another elegy, the fifth
elegy (there are still only ten in the book, because he threw out the
old fifth elegy and substituted this one). But the fifth of the elegies
is inspired by one of this series of pictures (not this particular
one). It is dedicated to Hertha Koenig in whose house he lived at
one time, who owned the picture to which the poem refers.

But tell me, who *are* they, these acrobats, even a little
more fleeting than we ourselves, — so urgently, ever since
 childhood,
wrung by an (oh, for the sake of whom?)
never-contented will? That keeps on wringing them,
bending them, slinging them, swinging them,
throwing them and catching them back; as though from an oily
smoother air, they come down on the threadbare
carpet, thinned by their everlasting
upspringing, this carpet forlornly
lost in the cosmos.

The poem goes on and then it comes to the crucial passage: there was a time when the acrobats could not perform terribly well, and, Rilke says, the important thing about love also is that you go through a time in which the whole thing is not working very well. And the question he asks himself is "What is the real meaning of life? Is it in the time when you are only learning things, or in that time when suddenly you have learned them?" And the sentiment in the end is that the very fact that this strolling acrobat is not very good, is more important than having perfect acrobats and that that applies particularly to life and to love.

Where, oh where in the world is that place in my heart
where they still were far from being *able*, still fell away
from each other like mounting animals, not yet
properly paired; —
where weights are still heavy,
and hoops still stagger
away from their vainly
twirling sticks?.....

That is so badly translated that I will give the original.

wo die Gewichte noch schwer sind;
wo noch von ihren vergeblich
wirbelnden Stäben die Teller
torkeln.....

And in some mysterious way "Teller" has become "hoops," whereas what he is talking about is Chinese jugglers twirling plates on the ends of their sticks and not being good enough, so that the plates fall off.

And then in this wearisome nowhere, all of a sudden
the ineffable spot where the pure too-little
incomprehensibly changes, — springs round
into that empty too-much.
Where the many-digited sum
solves into zero.

Und plötzlich in diesem mühsamen Nirgends, plötzlich
die unsägliche Stelle, wo sich das reine Zuwenig
unbegreiflich verwandelt —, umspringt
in jenes leere Zuviel.
Wo die vielstellige Rechnung
zahlenlos aufgeht.

And Rilke contrasts this with the modiste (like Renoir's little modiste) who is simply making do with life:

Squares, o square in Paris, infinite showplace,
where the modiste Madame Lamort
winds and binds the restless ways of the world,
those endless ribbons, to ever-new
creations of bow, frill, flower, cockade, and fruit,
all falsely colored, to deck
the cheap winter-hats of Fate.
 —für die billigen
Winterhüte des Schicksals.

We are at the end of the story. I started at the very beginning talking about the artifact. The work of art is an important artifact, and we must not overlook that this includes the book and the poem as well as the painting. When we see any artifact, we know both what it was made for and how it was made. I said that from this we derived the sense that the style and the content have to be the same thing if we are to enter into the work of art. We see that the work of art is an experiment in which, if we enter the life of other people, we experience the conflict of values which faces them. And this is true, whether the experiment that you are looking at is something about how you hold your brush or something about how the poem is put together: each is an experiment in human values in which we learn to know how life is affected by the balance of the choices that we make. I do not much like the way Rilke writes, frankly, but that very sense makes me read the poems again and again because I have the feeling that until I really get into that, until I really like the style as much as the content, I will not really understand the content. And the content, like the style, is an endless experiment in the act of living itself.

There are two phrases about the play of values that I used earlier on which I would like to end. One is that the human predicament is not that each of us is alone but that the problems of life have no unique and final solution. And the other is that the play of values in the work of art really says that we recognize ourselves in the artist as one of his creations and we recognize the whole creation in ourselves.

You will have noticed that the aesthetics that I have been developing through these six lectures are in the end rather heavily based on ethics. And you might think that I belong to the school of

philosophers who say that the beautiful must be founded on the good. But that traditional formulation in philosophy will not do. My view is that there is no such thing as a single good, and that ethics consists of a clear and unsentimental register of values which cannot be arranged into a single hierarchy, to be called "the good." I do not think that anywhere in life we can isolate an ultimate supreme value. The thing about life really is that you make goodness or you make the experience for yourself by constantly balancing the values that you have from moment to moment. And you have to have profound moments like that which Einstein had, and you must make profound mistakes, but you must always feel that you are exploring the values by which you live and forming them with every step that you take. On that I think the beautiful is founded. That, I think, is what the work of art says.

40
Queen Zenobia Addressing Her Soldiers, Giovanni Battista Tiepolo. Samuel H. Kress Collection, National Gallery of Art, Washington, D.C.

41
Liberty Leading the People,
Eugene Delacroix. National
Museums, Paris.

42
Napoleon Crowned with Laurels.
Wood engraving by J. B.
Thiebault, designed by Georgin. Musée Departmental des
Vosges (Epinal).

43
The Sacrament of the Last Supper,
Salvador Dali. Chester Dale
Collection, National Gallery of
Art, Washington, D.C.

44
Sketch for *The Last Supper*,
Leonardo da Vinci. Ac-
cademia, Venice.

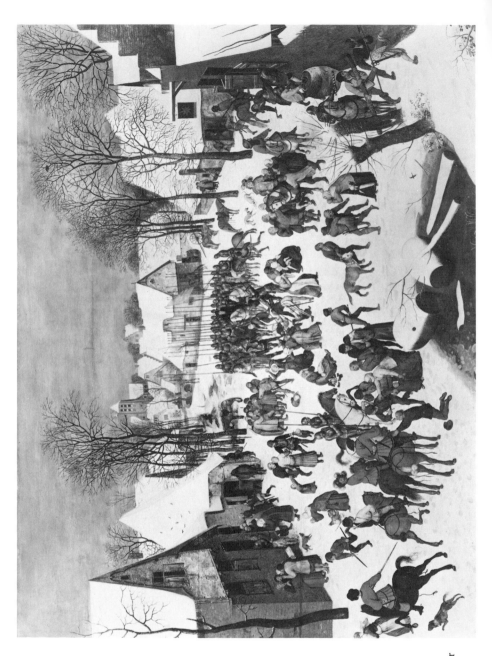

45
Massacre of the Innocents, Pieter Bruegel the Elder. Kunsthistorischen Museum, Vienna.

47
Les Parapluies, Pierre August Renoir. Reproduced courtesy of the Trustees, The National Gallery, London.

46
Detail from figure 45.

48
Family of Saltimbanques, Pablo Picasso. Chester Dale Collection, National Gallery of Art, Washington, D.C.

INDEX

182
Index